Offerings

MOMENTS OF MINDFULNESS
FROM THE MASTERS OF TIBETAN BUDDHISM

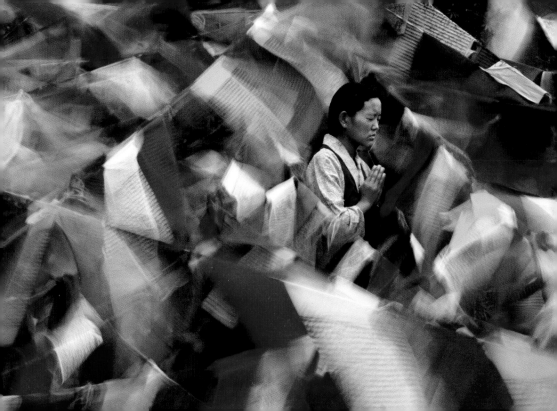

Danielle & Olivier Föllmi

Offerings

MOMENTS OF MINDFULNESS
FROM THE MASTERS OF TIBETAN BUDDHISM

Buddha Shakyamuni • His Holiness the 14th Dalai Lama • Pema Chödrön • Arnaud Desjardins
Dilgo Khyentse Rinpoche • Joseph Goldstein • Lama Anagarika Govinda
Kalu Rinpoche • Jack Kornfield • Milarepa • Matthieu Ricard • Sharon Salzberg
Shabkar • Shantideva • Chögyam Trungpa • Sogyal Rinpoche • Patrul Rinpoche

Abrams, New York

To Tenzin Motup, Tenzin Diskit, Nyima Lhamo, Tharpa Tsering and Pema Yangdun, our Tibetan children

A little town on the arid plains of India, Bodhgaya is the most sacred place in Buddhism. In January 2002, sitting cross-legged around the tree beneath which Buddha reached Enlightenment, thousands of monks in their red robes chanted prayers for world peace. All around them, three hundred thousand pilgrims who had come down from all the valleys of the Himalayas chanted with them, prayer beads in hand. It was here, in front of the tree of Buddha, in the overwhelming fervour of this

enormous choir, that the concept of this book came into being: to let this wish for peace shine out from every one of us.

This is a collection of messages from the masters of Tibetan Buddhism, from different schools and different eras, and the thoughts of the Western disciples that have been inspired by their teachings. The images in this book reflect the richness and diversity of the Buddhist Himalayas, from Tibet, India, Bhutan and Nepal.

May this book be of aid to every one of us
on the path to Enlightenment.

Danielle and Olivier Föllmi

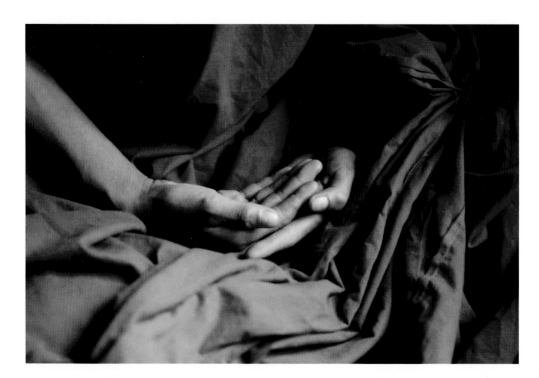

*One doesn't take a journey into the Himalayas
without a guide who knows the ancient paths.*

Jack Kornfield

IMPERMANENCE

Nothing is permanent:
the sun and the moon rise and then set,
the bright, clear day is followed by the deep, dark night.
From hour to hour, everything changes.

Kalu Rinpoche (1905–89)

At a height of 3,600 m (11,800 ft), the Buddhist monastery of Stongdey looks out over the plains of Zanskar, India.

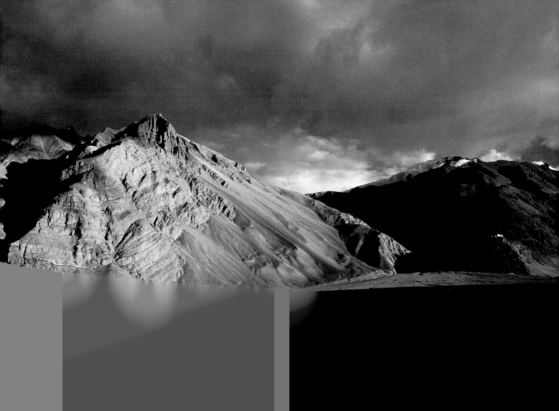

Impermanence is a principle of harmony. When we don't struggle against it, we are in harmony with reality.

Pema Chödrön

Candles lit as offerings in Bodhgaya, India, where the Buddha attained Enlightenment.

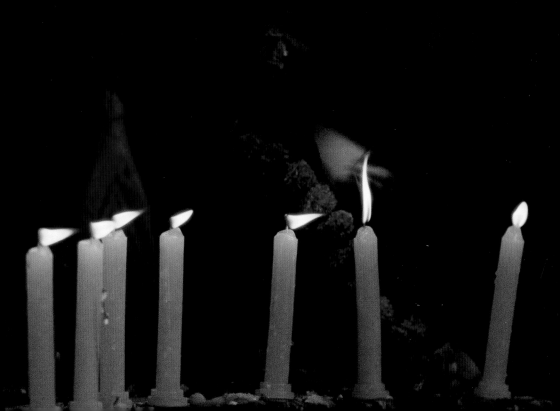

Suzuki Roshi summed up all the teachings of Buddhism in three simple words: 'Not always so.'

Jack Kornfield

A relic from the Chinese cultural revolution, an old boat lies on the bank of the Yarlung Tsangpo river in Tibet.

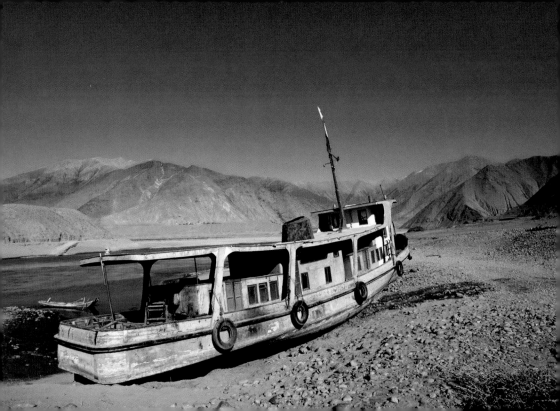

Perhaps the deepest reason why we are afraid
of death is because we do not know who we are.
We believe in a personal, unique and separate identity;
but if we dare to examine it, we find that this identity depends
entirely on an endless collection of things to prop it up; our name,
our 'biography', our partners, family, home, job, friends, credit cards....
It is on their fragile and transient support that we rely for our security.

Sogyal Rinpoche

Pupils are called to attention at the Tibetan Children's Village school in Choglamsar, Ladakh, India.

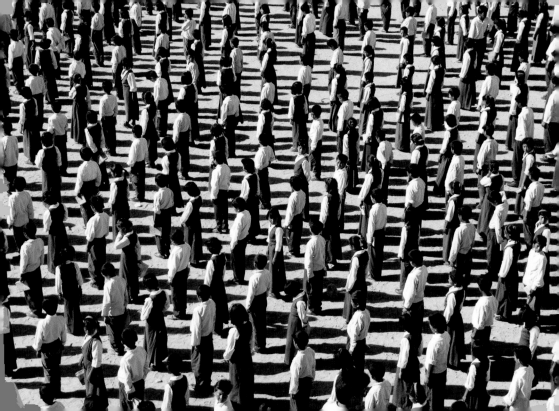

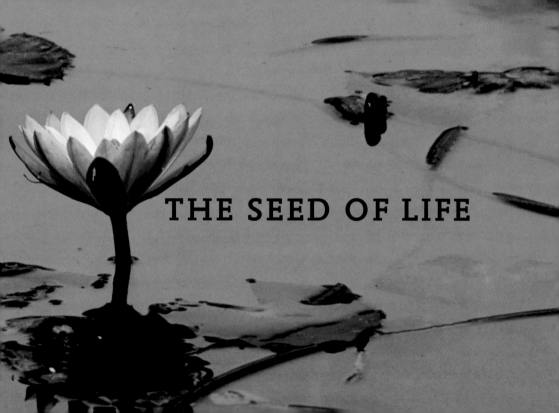

It is not easy to be reborn as a human being.
It is rarer than for a one-eyed turtle,
who rises to the surface only once every hundred years,
to push his neck through a wooden yoke with one hole
that floats on the surface of the wide ocean.

Buddha Shakyamuni (6th century BCE)

In Nepal, a village woman goes to market to sell her flowers, which will be made into garlands for use as offerings.

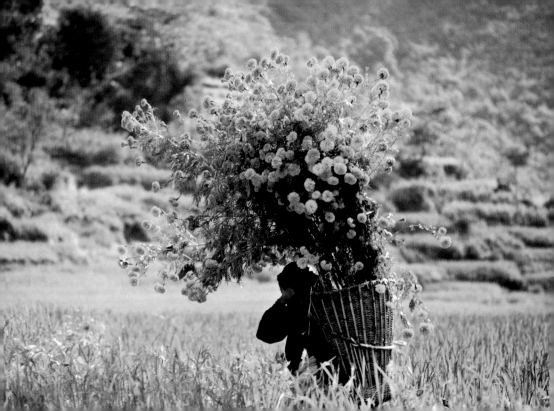

Let us try to recognize the precious nature of each day.

The 14th Dalai Lama

The first ray of sunshine reaches the deep valley of Barbung Khola in Nepal.

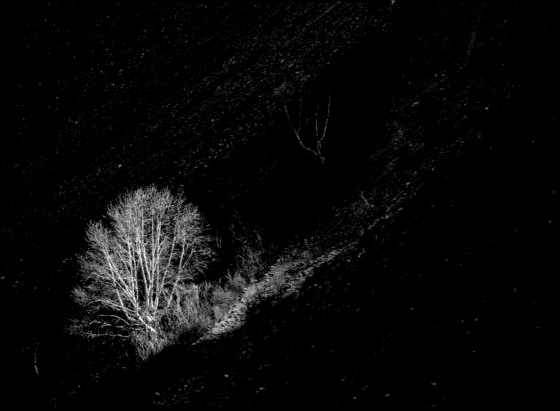

Like a robe wears out over time and turns to rags,
life wears out from day to day, from second to second.

Dilgo Khyentse Rinpoche (1910–91)

In Zanskar in the Himalayas, a patchwork curtain helps to keep the wind out of the chapel at Karcha monastery.

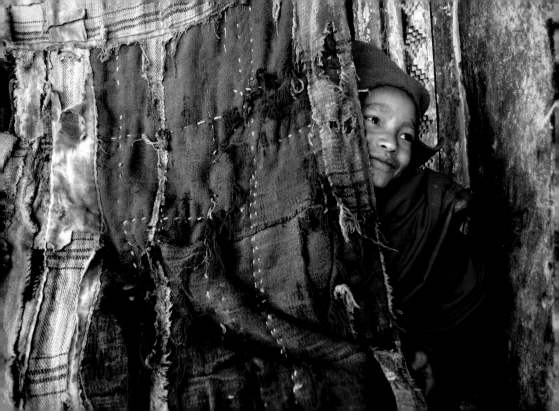

*Letting go is a central theme in spiritual practice,
as we see the preciousness and brevity of life.*

Jack Kornfield

A child dressed in festive clothes sleeps on his mother's lap during a religious celebration in Bhutan.

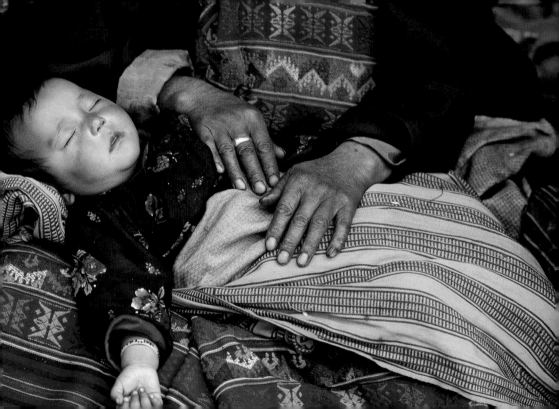

Terrible or not, difficult or not, the only thing that is beautiful, noble, religious and mystical is to be happy.

Arnaud Desjardins (1925–2011)

In the valley of Mustang, Nepal, a little girl smiles at the doorway to her home.

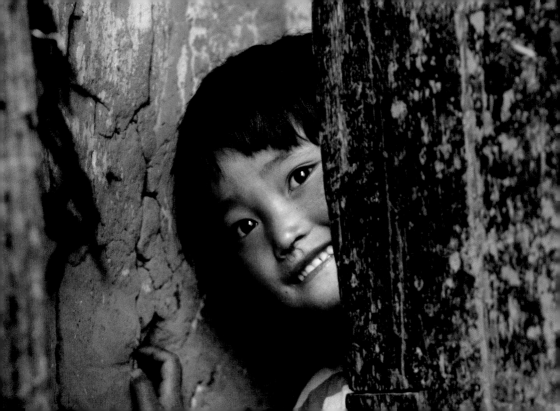

One who strives to attain Enlightenment must expect to encounter terrible obstacles: anger, desire, mental confusion, pride and jealousy.

Dilgo Khyentse Rinpoche (1910–91)

Crossing a swollen river during monsoon season to reach the Kangchenjunga massif in Sikkim, India.

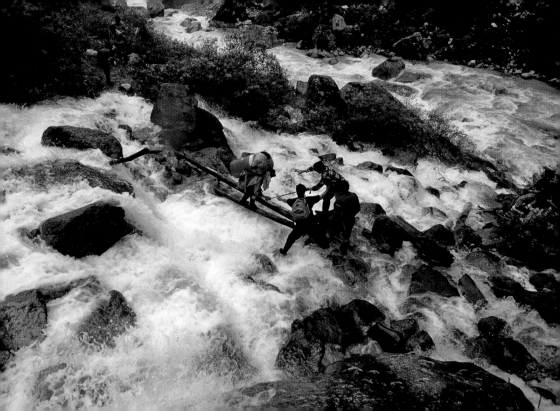

*Somehow, in the process of trying to deny that things are
always changing, we lose our sense of the sacredness of life.
We tend to forget that we are part of the natural scheme of things.*

Pema Chödrön

Autumn shadows fall over Schii, the highest village in Zanskar, India, at a height of 4,200 m (13,800 ft).

34

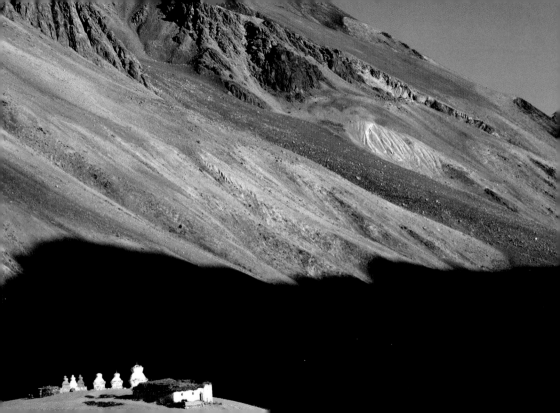

The trouble is that you think you have time.

Buddhist master, quoted by Jack Kornfield

Holding her prayer wheel, this elderly woman from Zanskar rests for a moment in the winter sunshine.

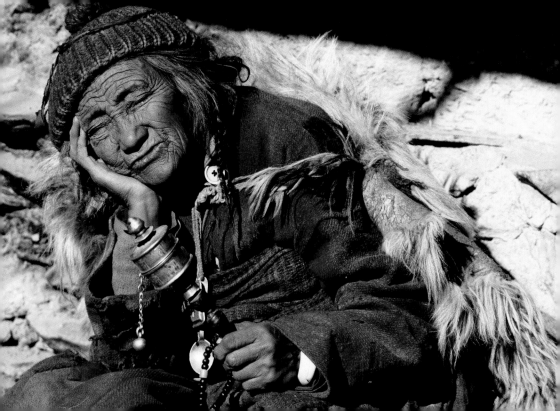

It's painful to face how we harm others, and it takes a while.
It's a journey that happens because of our commitment to gentleness
and honesty, our commitment to staying awake, to being mindful.

Pema Chödrön

When the Zanskar river freezes in winter, water sometimes covers the ice so travellers choose to walk barefoot.

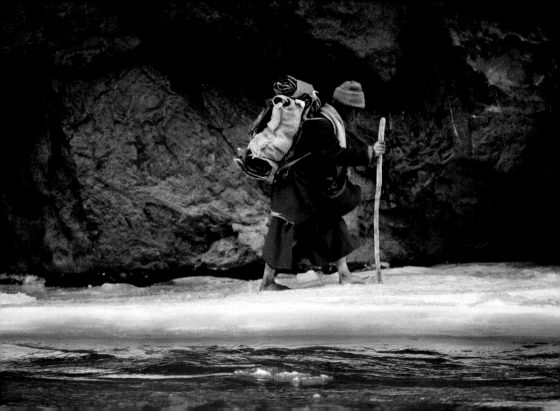

Fulfilling spiritual life can never come through imitation,
it must shine through our particular gifts and capacities as a
man or woman on this earth. This is the pearl of great price.

Jack Kornfield

A popular stone among Tibetans, turquoise symbolizes good luck and protection.

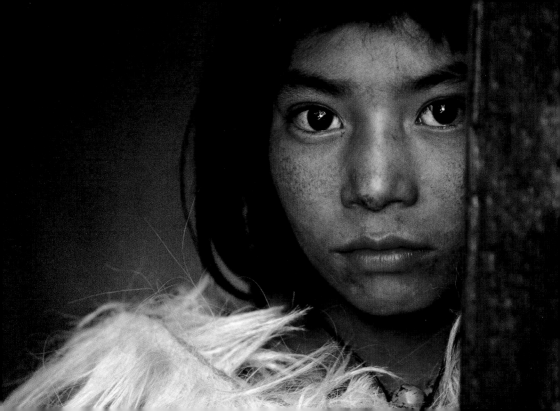

In honouring our own unique destiny,
we allow our most personal life to become
an expression of the Buddha in a new form.

Jack Kornfield

Two young monks walk to the chapel of the Trongsa Dzong in Bhutan, for daily prayers.

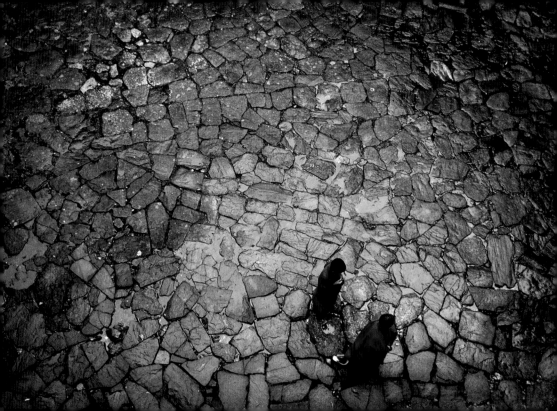

Every individual in the world has a unique contribution.

Jack Kornfield

In the valley of Zanskar, at a height of 3,800 m (12,500 ft), a man from the village of Cha proudly carries his twin sons.

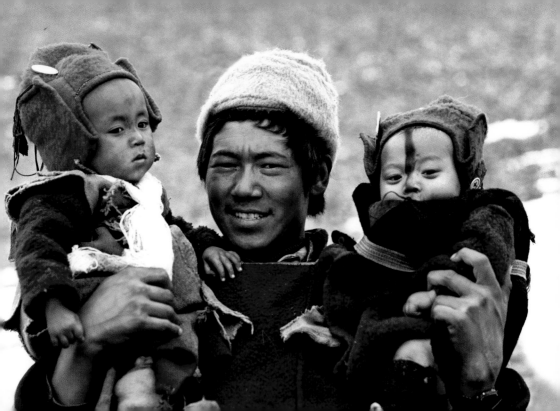

We can awaken to basic goodness, our birthright.

Pema Chödrön

In Zanskar in the Indian Himalayas, it is 0°C (32°F) when Tsering wakes up.

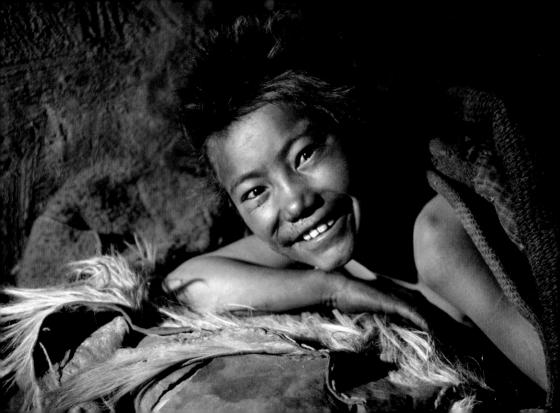

Do not take lightly small good deeds,
Believing they can hardly help.
For drops of water, one by one,
In time can fill a giant pot.

Patrul Rinpoche (1808–87)

In Tibet, a ferryman carries shepherds between the banks of the Yarlung Tsangpo river.

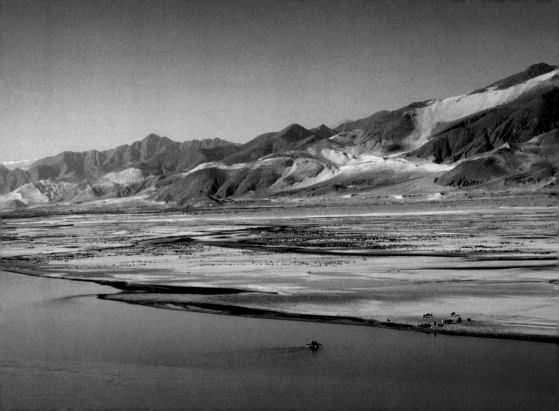

We are the sum of a huge number of free actions
for which we are the only ones responsible.

Matthieu Ricard

A group of travelling performers from Spiti play to a crowd of amazed shepherds at Korzok in the Indian Himalayas.

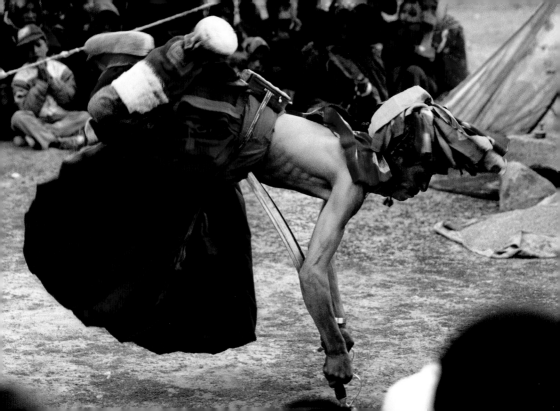

The better we understand the nature of mind, the more deeply we will be able to see into the endless chain of cause and effect that is karma. This understanding not only allows us to avoid or reduce the negative actions which harm others or ourselves and the suffering caused by these, but also lets us cultivate and increase positive actions which create well-being and happiness.

Kalu Rinpoche (1905–89)

In autumn in the Mustang valley, Nepal, women sing as they winnow barley.

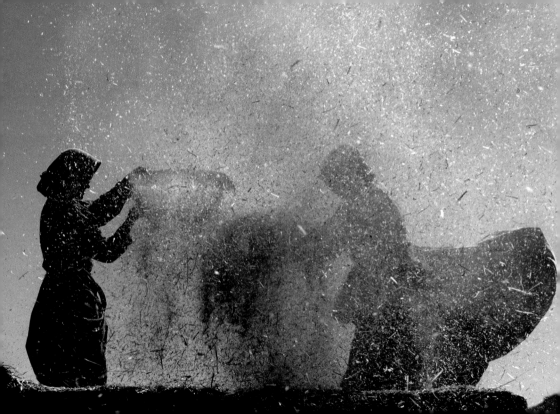

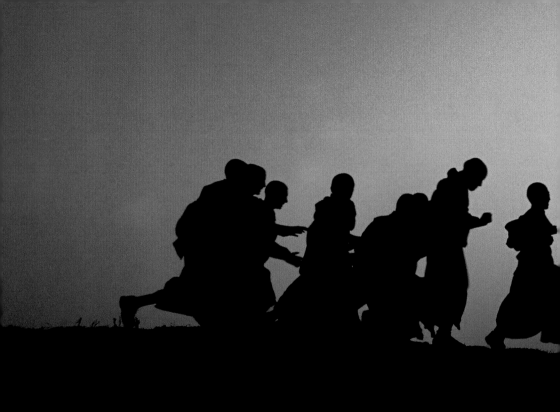

COMING TO LIFE

Whether we regard our situation as heaven
or as hell depends on our perception.

Pema Chödrön

An encampment at 6,800 m (22,300 ft), en route for the summit of Minya Konka in Tibet, 7,556 m (24,790 ft) high.

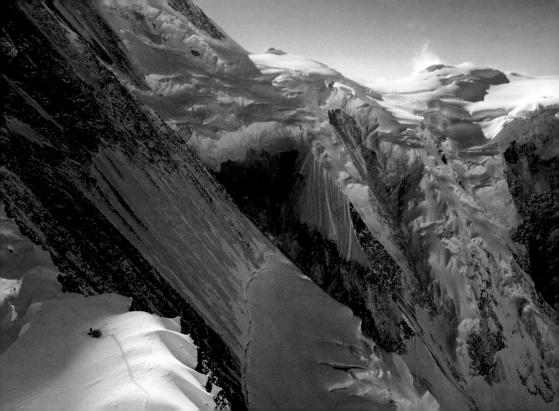

Peace of mind is rooted in affection and compassion.

The 14th Dalai Lama

A Bhutanese boy accompanies his uncle, a monk, on a Buddhist pilgrimage to Bodhgaya, India.

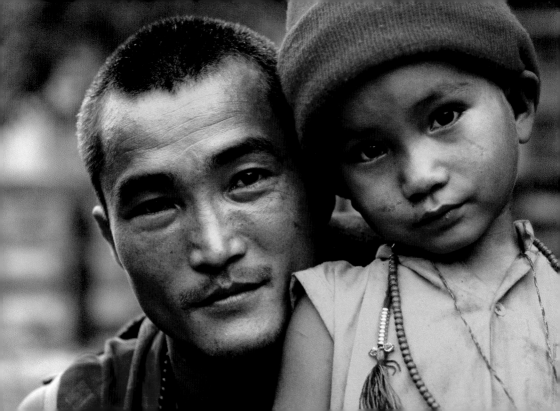

To see the preciousness of all things,
we must bring our full attention to life.

Jack Kornfield

In Zanskar, India, a young monk polishes a copper pot used to pour tea for the community.

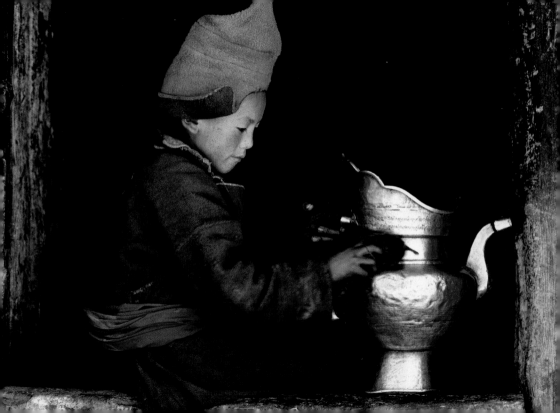

If there are obstacles, it cannot be space,
If there are numbers, it cannot be stars,
If it moves and shakes, it cannot be a mountain,
If it grows and shrinks, it cannot be an ocean,
If it must be crossed by a bridge, it cannot be a river,
If it can be grasped, it cannot be a rainbow.
These are the six parables of outer perception.

Milarepa (c. 1040–1123)

An esoteric symbol of the path to Enlightenment, a chorten always marks the entrance to Tibetan holy places.

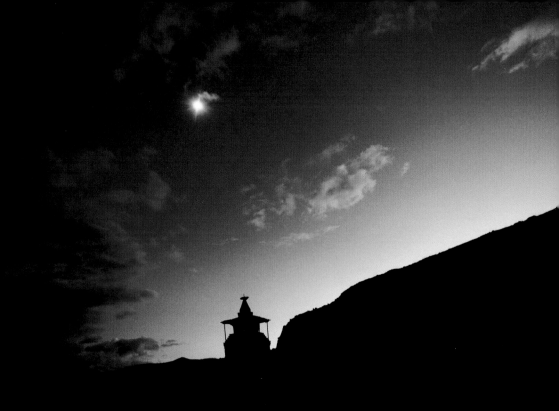

The things that matter most in our lives are not fantastic or grand.
They are the moments when we touch one another.

Jack Kornfield

In the Indian Himalayas, porters cross the Zanskar river barefoot, although the temperature is -30°C (-22°F).

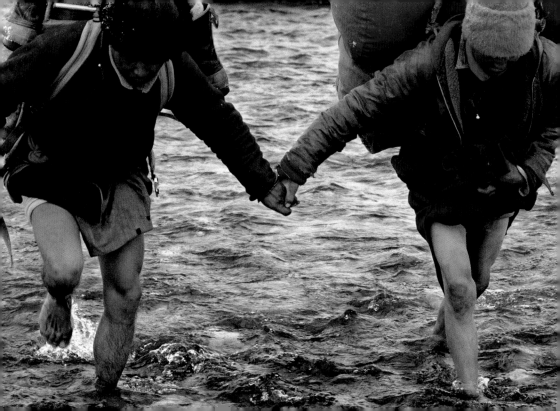

It is only through constant training that our practice will grow steady and we will be able to control our negative tendencies fearlessly.

Dilgo Khyentse Rinpoche (1910–91)

A precarious way to cross the rushing monsoon river to reach the Kangchenjunga massif in Sikkim, India.

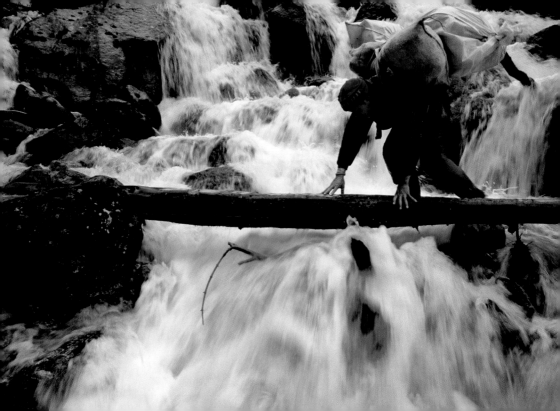

We are all slaves of our own actions.
Why be angry with anyone else?

Shantideva (c. 685–763)

Surrounded by incense smoke from the Jokhang Temple, Lhasa, a Chinese police officer checks a Tibetan woman's papers.

When we feel responsible, concerned and committed,
we begin to feel deep emotion and great courage.

The 14th Dalai Lama

In a lively speech, the 14th Dalai Lama stresses that it is everyone's responsibility to improve the fate of humanity.

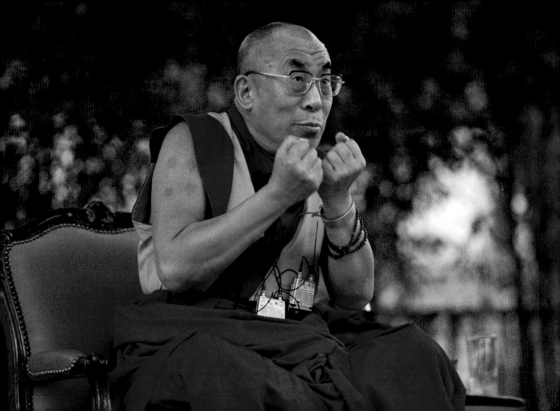

Each individual is master of his or her destiny:
it is up to each person to create the causes of happiness.

The 14th Dalai Lama

A village woman from the isolated Barbung valley in Nepal spends the autumn gathering wood for the winter.

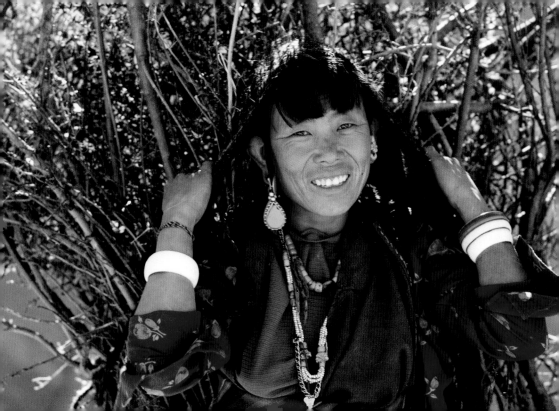

Not causing harm requires staying awake.
Part of being awake is slowing down enough to notice what we say and do.
The more we witness our emotional chain reactions and understand
how they work, the easier it is to refrain. It becomes a way of life
to stay awake, slow down, and notice.

Pema Chödrön

A Tibetan Buddhist monk prays in a family chapel in the valley of Zanskar, India.

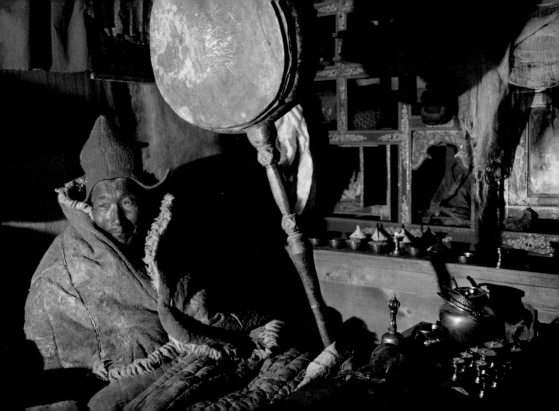

When one intends to move or speak,
one should first examine one's own mind
and then act appropriately with composure.

Shantideva (c. 685–763)

Breaktime in the monsoon rain for the schoolchildren from the Tibetan Children's Village in Dharamsala, India.

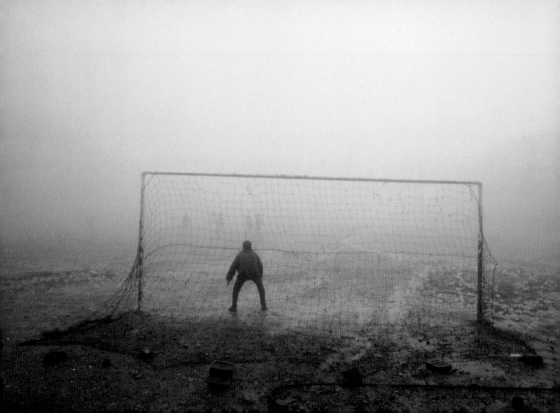

The ordinary mind is the ceaselessly shifting and shiftless prey
of external influences, habitual tendencies, and conditioning;
the masters liken it to a candle flame in an open doorway,
vulnerable to all the winds of circumstance.

Sogyal Rinpoche

Butter lamps burn during a prayer for peace to honour the Buddha's teachings in Bodhgaya, India.

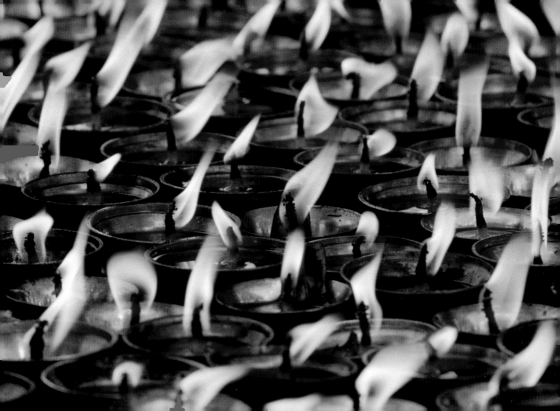

We live under threat from painful emotions:
anger, desire, pride, jealousy and so on.
Therefore we should always be ready to counter these
with the appropriate antidote. True practitioners
may be recognized by their unfailing mindfulness.

Dilgo Khyentse Rinpoche (1910–91)

In a mountain pass in Bhutan, a wall of stones carved with prayers invoke the Buddha of Compassion.

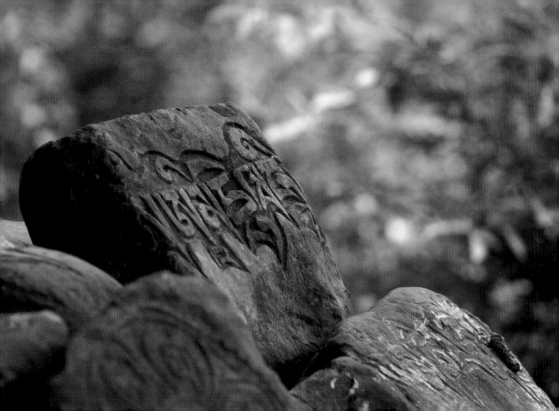

Instead of allowing ourselves to be led and trapped by our feelings,
we should let them disappear as soon as they form,
like letters drawn on water with a finger.

Dilgo Khyentse Rinpoche (1910–91)

At a height of more than 5,000 m (16,400 ft), the Himalayan valleys of Rupshu, India, lie bathed in autumn light.

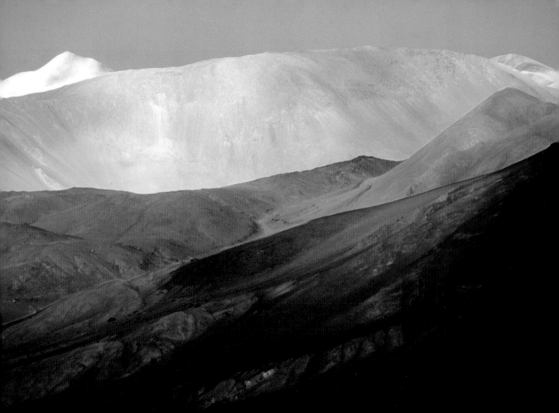

Reaching a state of inner freedom as regards emotions does not mean being apathetic or insensitive, nor does it mean that existence loses its colour in the slightest. It simply means that, instead of always being the plaything of our negative thoughts, moods, and temperaments, we become their masters.

Matthieu Ricard

In Zanskar in the Himalayas, a villager heads home on horseback, dressed in his warm woollen *goncha*.

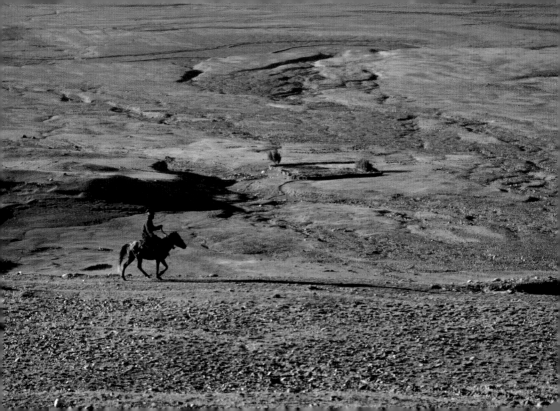

The creations of the mind are more numerous
than specks of dust in a ray of sunlight.

Milarepa (*c.* 1040–1123)

A storm gathers over the village of Photoksar, in the valleys between Ladakh and Zanskar at a height of 3,800 m (12,500 ft).

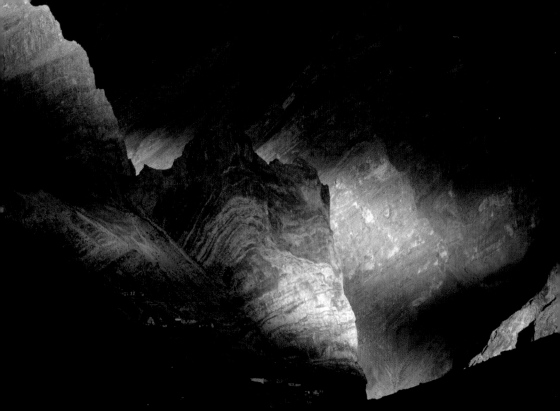

We live a form of false perception of reality.

Matthieu Ricard

In Zanskar, India, this wooden ladder leads to a roof terrace where animal fodder is stored.

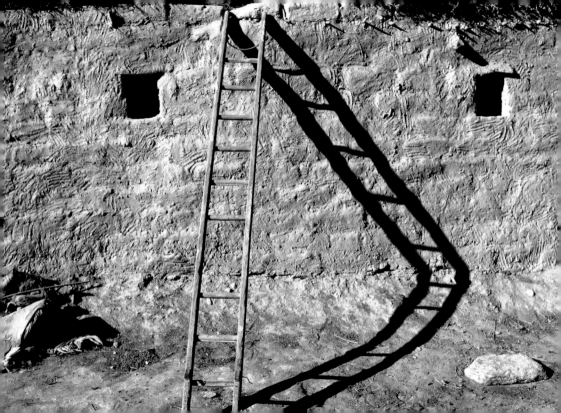

Do not encumber your mind with useless thoughts.
What good does it do to brood on the past or anticipate the future?
Remain in the simplicity of the present moment.

Dilgo Khyentse Rinpoche (1910–91)

These children in Zanskar have made their own skis from wooden planks, scrap metal and string.

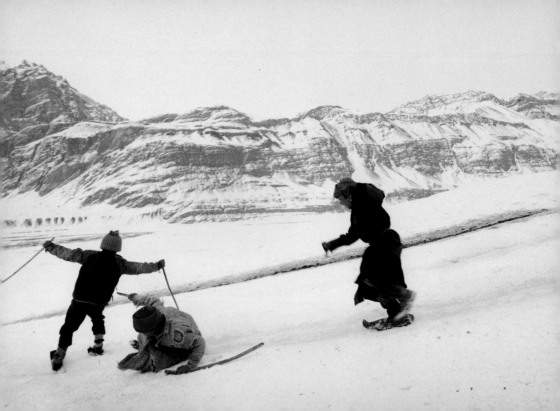

*Achieving genuine happiness may require bringing about
a transformation in your outlook, your way of thinking,
and this is not a simple matter.*

The 14th Dalai Lama

A young novice learns about monastic life at the Buddhist monastery of Karcha in Zanskar, India.

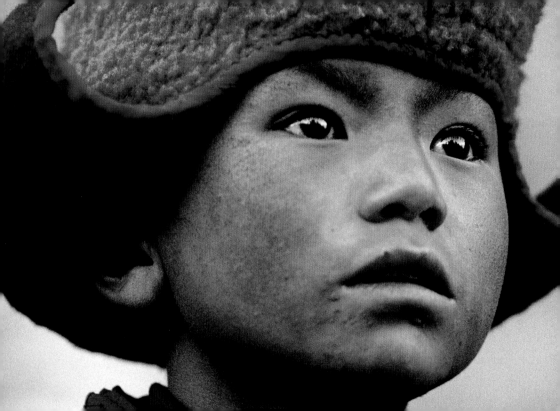

*To exercise right mindfulness, the mind must be neither too taut,
nor too relaxed, like the string of a* vina.

Kalu Rinpoche (1905–89)

To earn money for his pilgrimage, a Tibetan musician plays his *vina* on the road to Mount Kailash, the sacred mountain.

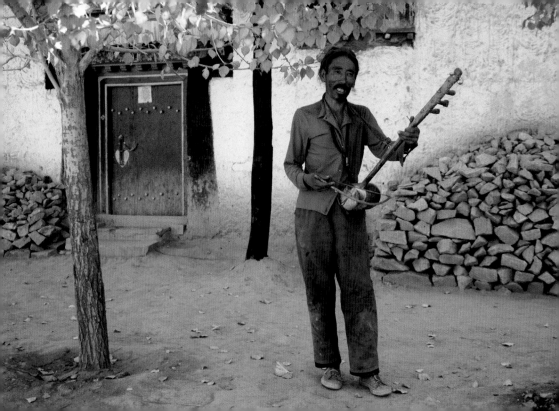

The more sophisticated the level of our knowledge is,
the more effective we will be in dealing with the natural world.

The 14th Dalai Lama

A villager heads home on foot through the leafy autumn forests of Bhutan.

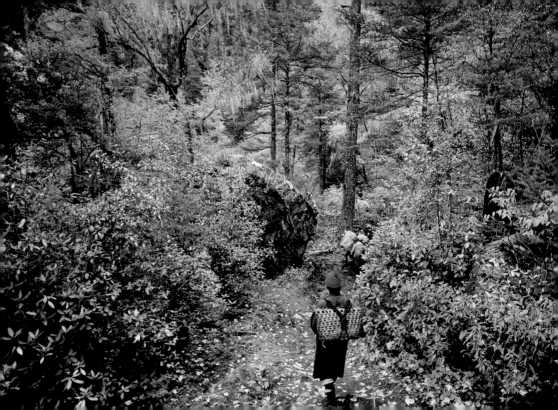

SAMSARA
& REBIRTH

It is our mind, and that alone,
that chains us or sets us free.

Dilgo Khyentse Rinpoche (1910–91)

In the Himalayas, the summer monsoon may help the harvests or could damage them if it is too heavy.

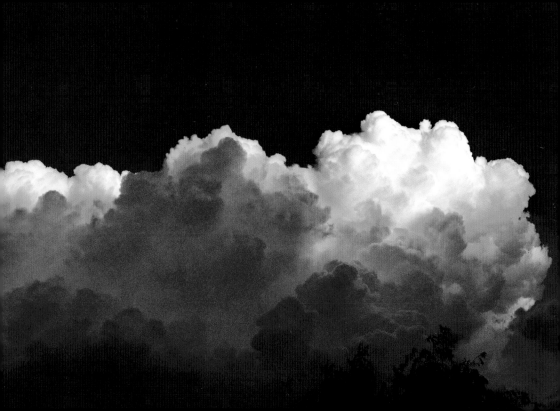

Our lives are lived in intense and anxious struggle,
in a swirl of speed and aggression, in competing,
grasping, possessing and achieving,
forever burdening ourselves with
extraneous activities and preoccupations.

Sogyal Rinpoche

The bustling bazaar of Bodhgaya, India, during a pilgrimage that brings Tibetan Buddhists together.

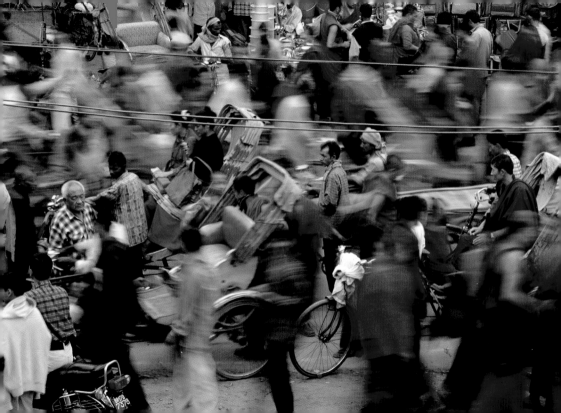

Becoming immersed in these four pairs
of opposites – pleasure and pain, loss and gain,
fame and disgrace, and praise and blame –
is what keeps us stuck in the pain of samsara.

Pema Chödrön

A yak caravan crosses the Ngile pass in Bhutan, at a height of 4,810 m (15,780 ft), to reach isolated villages.

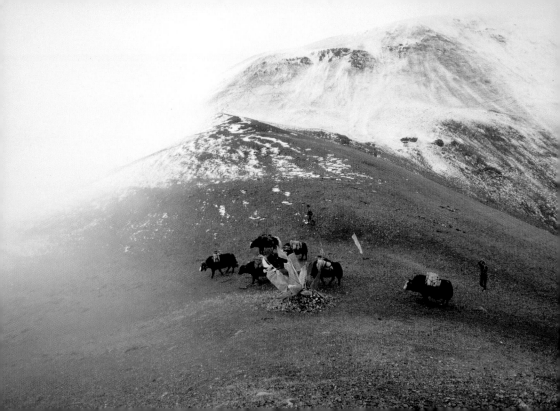

*Thinking that we can find some lasting pleasure
and avoid pain is what in Buddhism is called samsara,
a hopeless cycle that goes round and round
endlessly and causes us to suffer greatly.*

Pema Chödrön

The bazaar in Bodhgaya, India, during an initiation for peace in the heart given by the Dalai Lama.

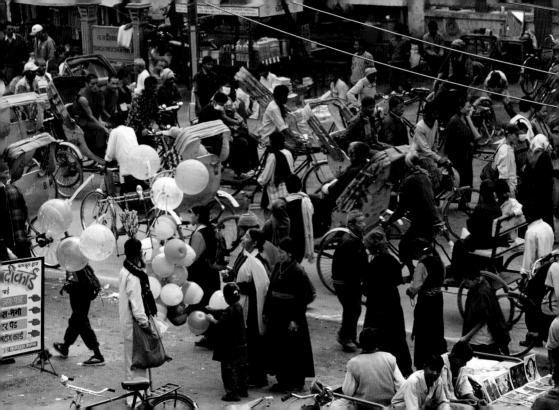

We can always begin again.

Jack Kornfield

The sacred mountain of Jomolhari, at a height of 7,326 m (24,035 ft), is the highest peak in Bhutan.

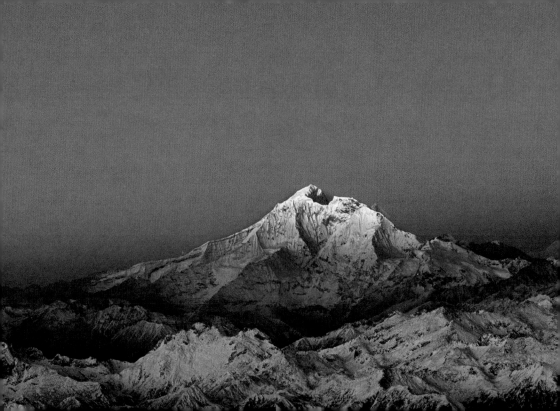

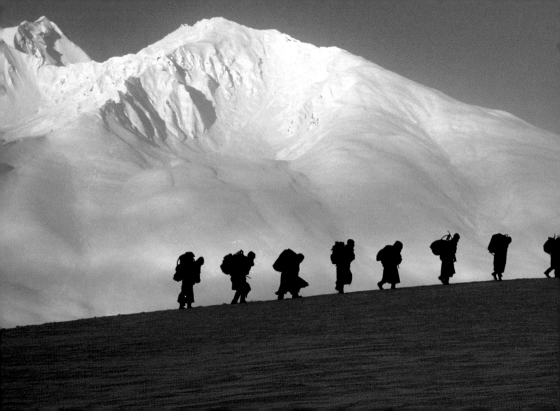

GROWING

We must look at our life without sentimentality, exaggeration or idealism.
Does what we are choosing reflect what we most deeply value?

Jack Kornfield

At the foot of the sacred mountain of Swayambhunath in Nepal, a monk sells portraits of spiritual masters.

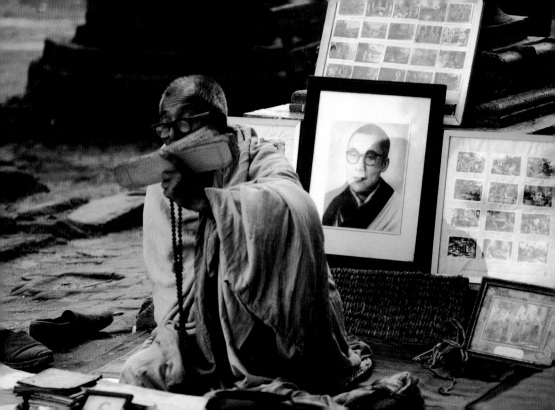

We must especially learn the art of directing mindfulness into the closed areas of our life.

Jack Kornfield

Barbed wire fences protect the crops in Zanskar, India.

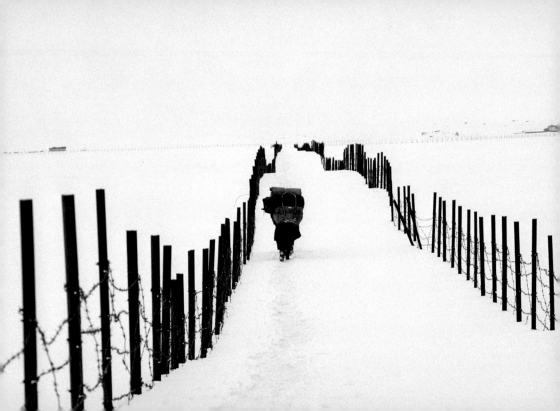

On days when the sky is grey, the sun has not disappeared forever.

Arnaud Desjardins (1925–2011)

A little boy daydreams in an isolated house in the high region of Ladakh, India.

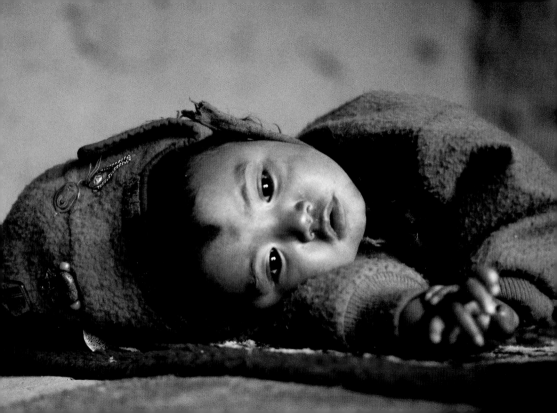

Confined in the dark, narrow cage of our own making
which we take for the whole universe,
very few of us can even begin to imagine
another dimension of reality.

Sogyal Rinpoche

Tsering teaches at the local school in the village of Zongla in Zanskar, India.

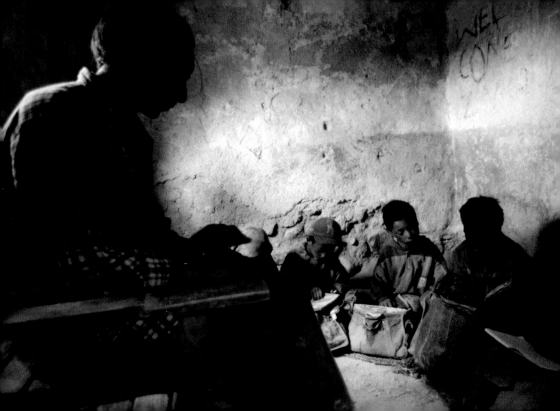

The most important thing is the way we act from moment to moment in our everyday life, just as it happens. To escape from the nightmare, we must build an inner structure over which the mind has no hold, and which spans all areas of our lives: intellectual, emotional, sexual.

Arnaud Desjardins (1925–2011)

At their winter home in Zanskar, a great-grandmother teaches her great-granddaughter to dance.

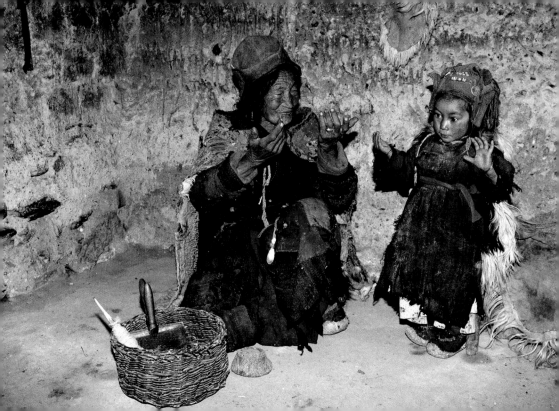

What counts is not the enormity of the task,
but the size of the courage.

Matthieu Ricard

Above the Mustang valley in Nepal, a mule caravan climbs up to the Lungpa pass, at a height of 5,410 m (17,750 ft).

What we're talking about is getting to know fear,
becoming familiar with fear, looking it right in the eye –
not as a way to solve problems, but as a complete undoing of
old ways of seeing, hearing, smelling, tasting and thinking.
The truth is that when we really begin to do this,
we're going to be continually humbled.

Pema Chödrön

A caravan of porters battle against heavy snows to reach the high valley of Zanskar.

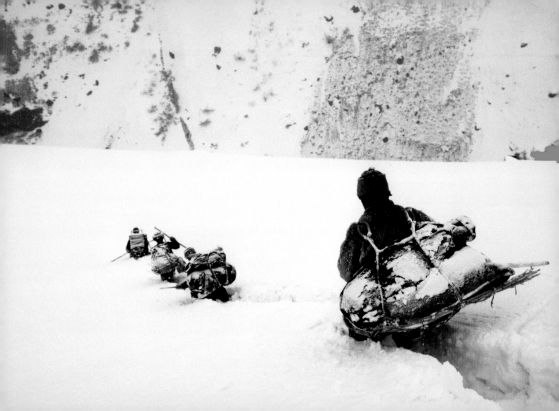

It seems that often when problems arise,
our outlook becomes narrow.

The 14th Dalai Lama

At a height of 3,600 m (11,800 ft), the Tibetan Buddhist monastery of Karcha in Zanskar is home to 150 monks.

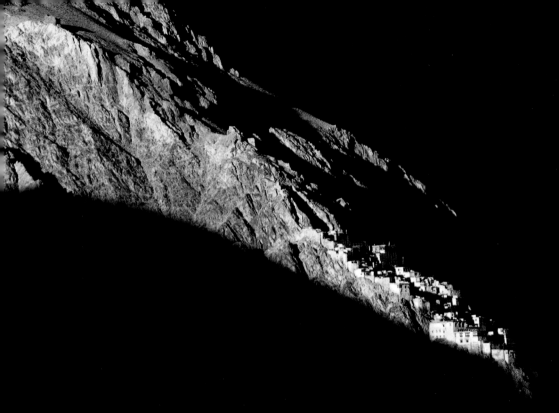

Feelings like disappointment, embarrassment, irritation, resentment, anger, jealousy, and fear, instead of being bad news, are actually very clear moments that teach us where it is that we're holding back.

Pema Chödrön

In the deep canyon of the Zanskar river in the Indian Himalayas.

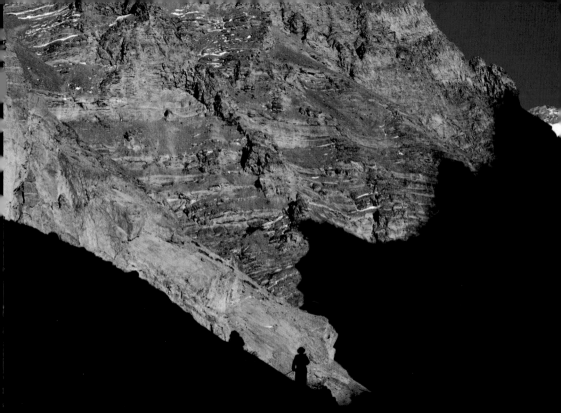

Learning to live is learning to let go.

Sogyal Rinpoche

In Zanskar, India, a child takes a nap under a goatskin blanket.

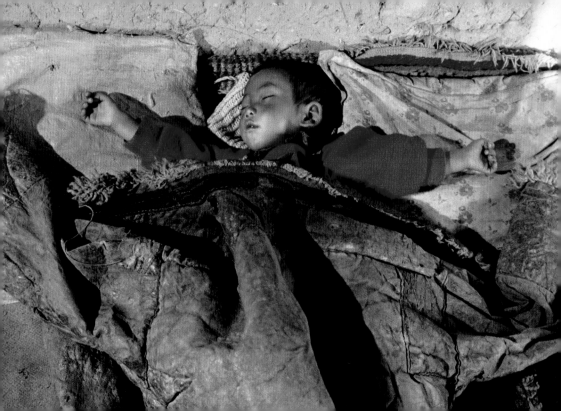

Things falling apart is a kind of testing and also a kind of healing.

Pema Chödrön

Refugee Tibetan monks and nuns take part in a demonstration for the freedom of Tibet in Dharamsala, India.

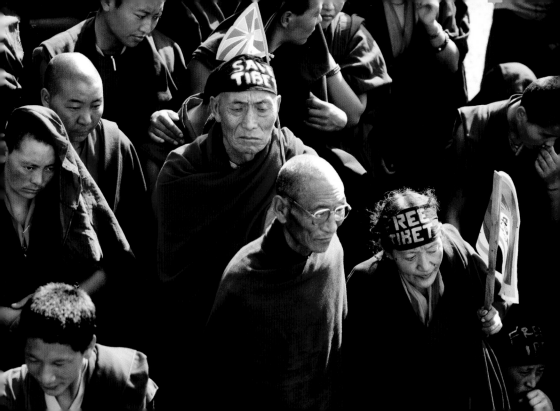

When there's a disappointment, I don't know if it's the end of the story. But it may be just the beginning of a great adventure.

Pema Chödrön

On the Chadar trail in Zanskar, at a height of 3,400 m (11,200 ft), a caravan is hit by an unexpected snowstorm.

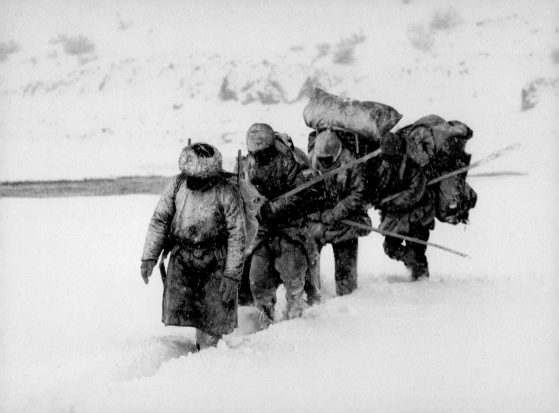

Our hearts can grow strong at the broken places.

Jack Kornfield

In the Indian Himalayas, the Chadar trail connects Ladakh and Zanskar via a frozen river.

Enemies such as craving and hatred are without arms or legs.
They are neither courageous nor wise.
How is it that they have enslaved me?

Shantideva (c. 685–763)

Printed prayer flags can be seen all over the Buddhist Himalayas.

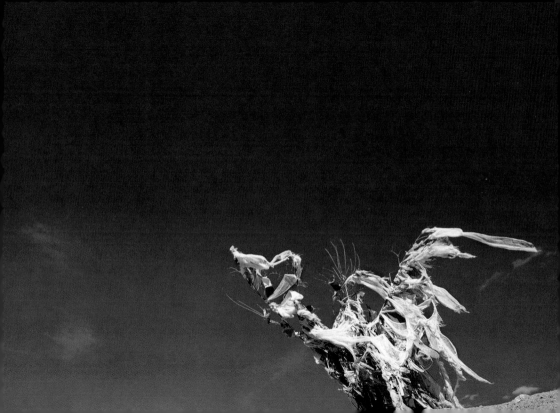

We continue to create suffering, waging war with good,
waging war with evil, waging war with what is too small,
waging war with what is too big, waging war with what is too short
or too long, or right or wrong, courageously carrying on the battle.

Jack Kornfield

A spider weaves a web in a bush in Sikkim, India.

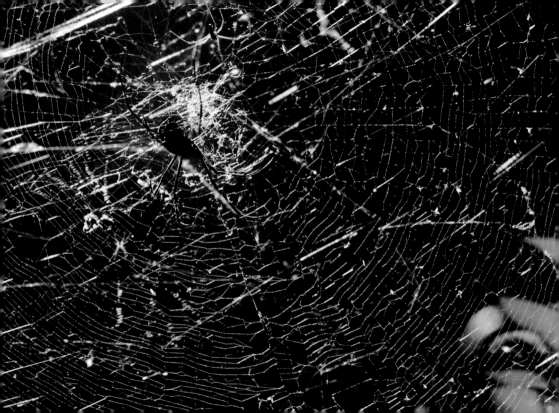

Western laziness consists of cramming our lives with compulsive activity,
so that there is no time at all to confront the real issues.

Sogyal Rinpoche

The Himalayan road between Srinagar and Leh in India is made up of almost 450 km (280 miles) of dangerous bends.

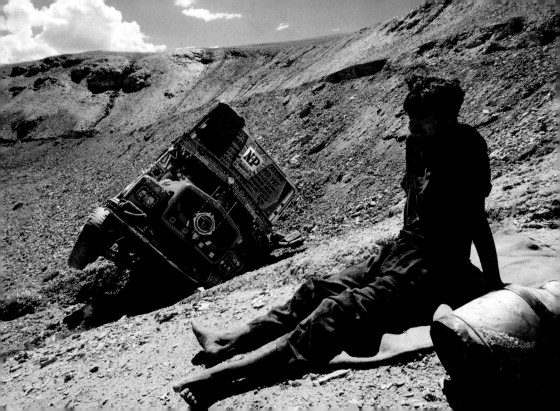

You are encouraged to say to your ego:
'You have created tremendous trouble for me,
and I don't like you. I'm going to destroy you.'

Chögyam Trungpa (1939–1987)

In Tibet, the yak is highly valued for its strength and endurance, but it can be a wilful animal.

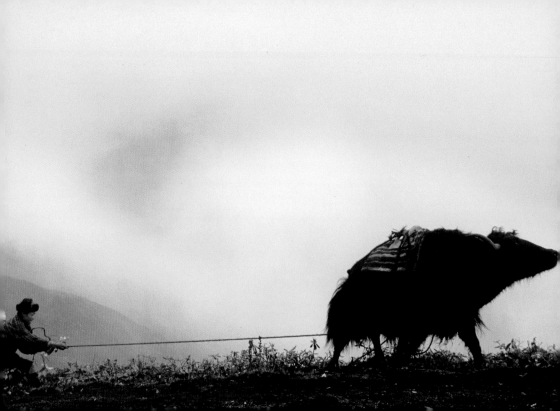

Yes *and* thank you *are the opposites of selfishness.*
The ego can only be erased through happiness and gratitude.

Arnaud Desjardins (1925–2011)

The Tibetan Children's Village in northern India.

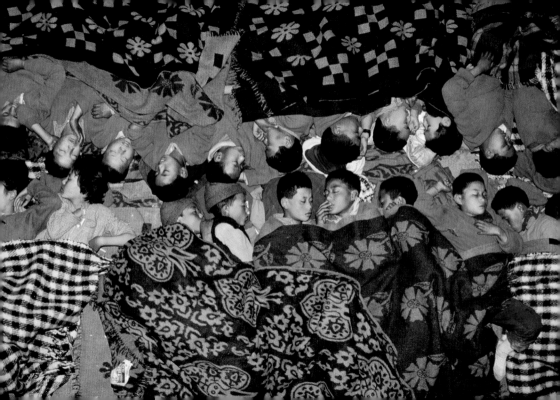

You should begin to build up confidence and joy in your own richness.
That richness is the essence of generosity. It is the sense of resourcefulness,
that you can deal with whatever is available around you
and not feel poverty-stricken.

Chögyam Trungpa (1939–1987)

The children of Zanskar, in the Indian Himalayas, still manage to have fun when the temperature is -20°C (-4°F).

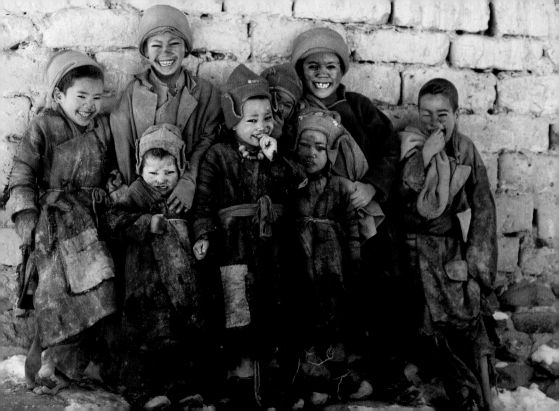

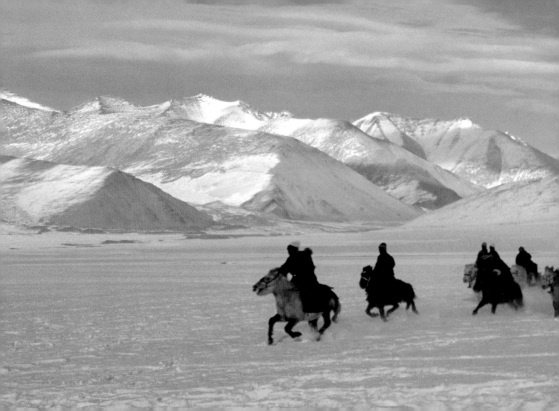

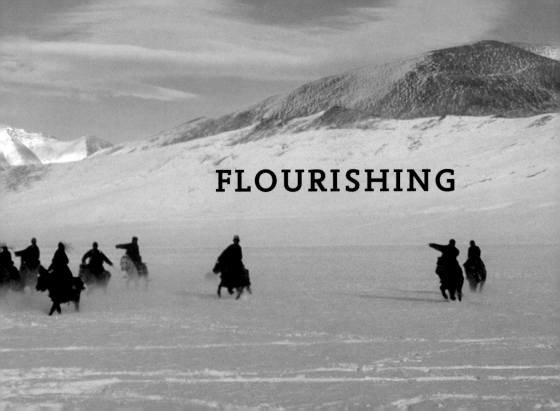

FLOURISHING

The essence of Buddhism:
'No self, no problem.'

Jack Kornfield

A young Tibetan dressed in Chinese style in a café in Lhasa, Tibet.

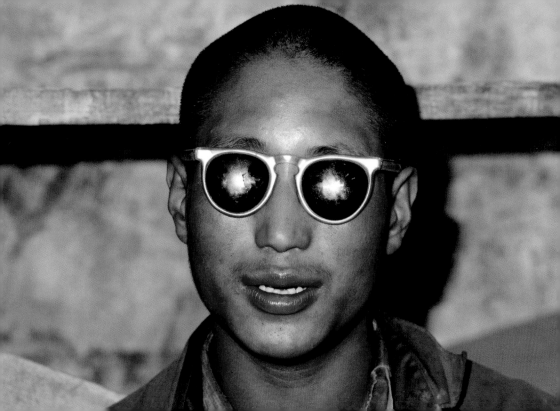

To take the one seat is to discover that we are unshakable.

Jack Kornfield

A mother and child from the Dolpo valley, Nepal.

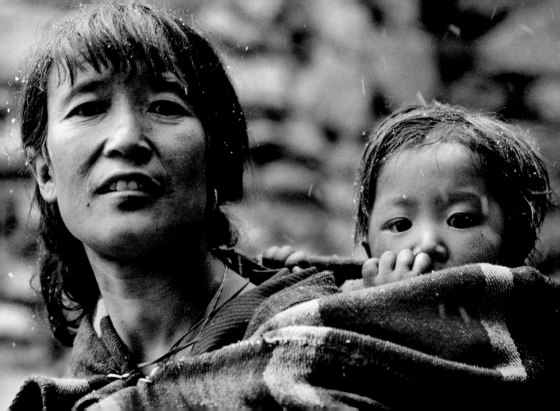

Humility does not mean believing oneself to be inferior, but to be freed from self-importance. It is a state of natural simplicity which is in harmony with our true nature and allows us to taste the freshness of the present moment.

Matthieu Ricard

In winter, shepherds return to the isolated camp of Tasaphuk, in the high valleys of Ladakh.

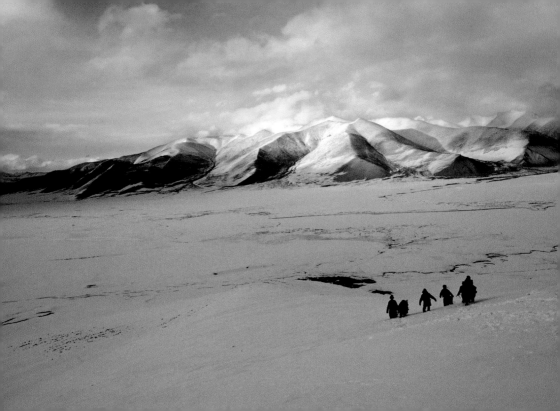

The rich never have enough money,
and the powerful never have enough power.
Let us reflect: the best way to satisfy all our desires and
make all our plans come to fruition is to let them go.

Dilgo Khyentse Rinpoche (1910–91)

Leopard skins on sale at the market in the old quarter of Lhasa, Tibet.

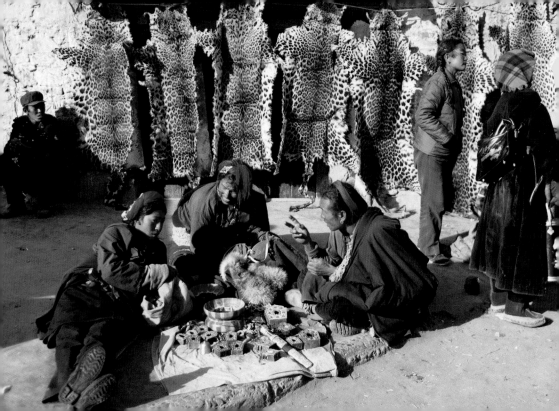

Children, old people, vagabonds laugh easily and heartily:
they have nothing to lose and hope for little.
In renunciation lies a delicious taste of simplicity and deep peace.

Matthieu Ricard

In Zanskar, little Nonole wakes up in the family's winter home.

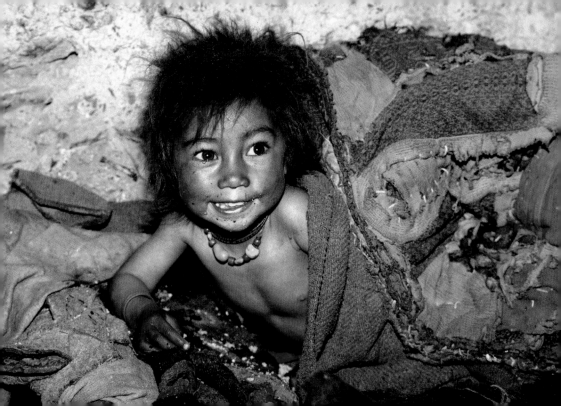

The key is changing our habits and,
in particular, the habits of our mind.

Pema Chödrön

In autumn, strong gusts of wind regularly sweep the plain of Zanskar, at a height of 3,500 m (11,500 ft).

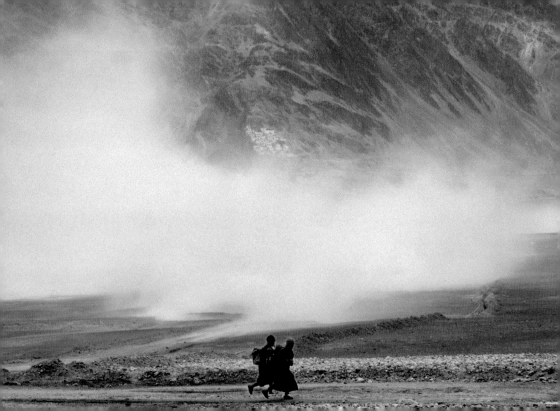

From possessiveness is born need;
from non-attachment, satisfaction.

Kalu Rinpoche (1905–89)

Pencil case belonging to a pupil at the Tibetan Children's Village school in Choglamsar in Ladakh.

Want what you have and don't want what you don't have.
Here you will find true fulfilment.

Jack Kornfield

Tarchen and his son Karma at their winter home in Ladakh, India.

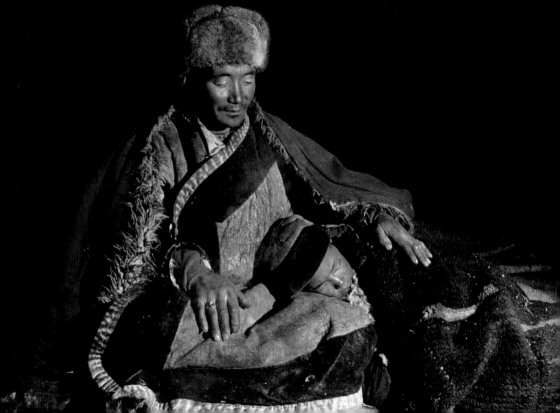

*We can gradually drop our ideals of who we think we ought to be,
or who we think we want to be, or who we think
other people think we want to be or ought to be.*

Pema Chödrön

A mother and her children walk along the shore of Lake Moriri in Ladakh, at a height of 4,000 m (13,100 ft).

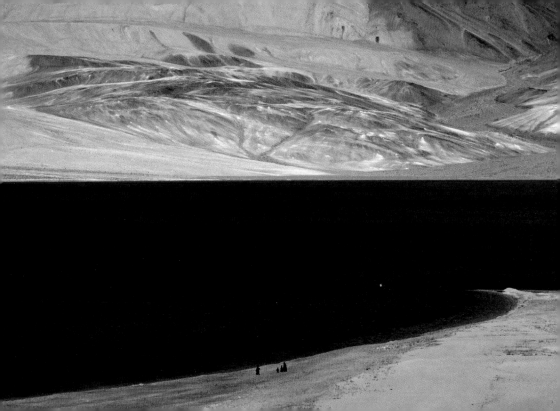

My bed is small, but I rest at ease.
My clothes are thin, but my body is warm.
My food is scarce, but I am nourished.

Milarepa (*c.* 1040–1123)

A young shepherdess stops to breastfeed her child on the way to the camp of Tso Khar in Ladakh, India.

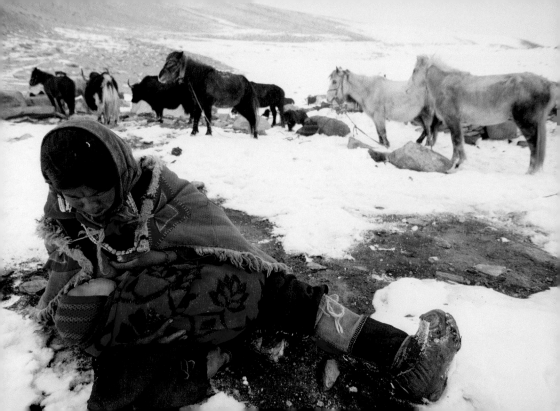

You can't stop the waves,
but you can learn to surf.

Joseph Goldstein

Himalayan streams are very violent in summertime, owing to the monsoon rains and the melting snow.

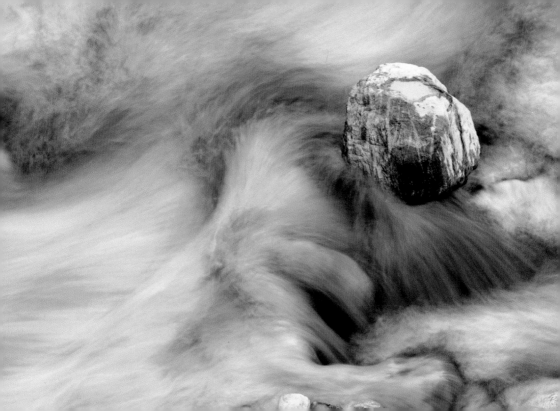

A balanced and skilful approach to life, taking care to avoid extremes, becomes a very important factor in conducting one's everyday existence.

The 14th Dalai Lama

A pupil at the Tibetan Children's Village school in Patlikuhl, India, does a handstand in the school yard.

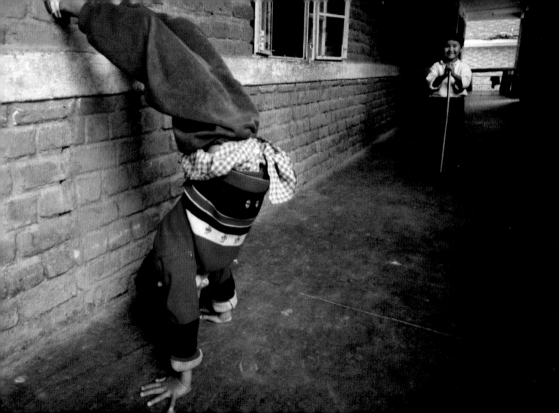

Life is movement.
The more life there is, the more flexibility there is.
The more fluid you are, the more you are alive.

Arnaud Desjardins (1925–2011)

A celebration at the Tibetan Children's Village school in Patlikuhl, India.

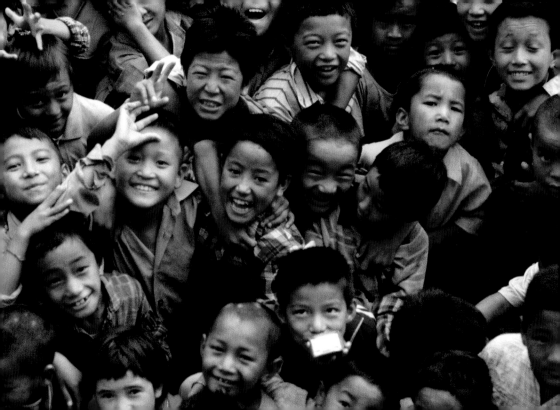

In a society that almost demands life at double time,
speed and addictions numb us to our own experience.
In such a society it is almost impossible to settle
into our bodies or stay connected with our hearts, let alone
connect with one another or the earth where we live.

Jack Kornfield

On a pilgrimage to Lhasa, Tibet, two women from Amdo sit down outside the sacred Jokhang Temple.

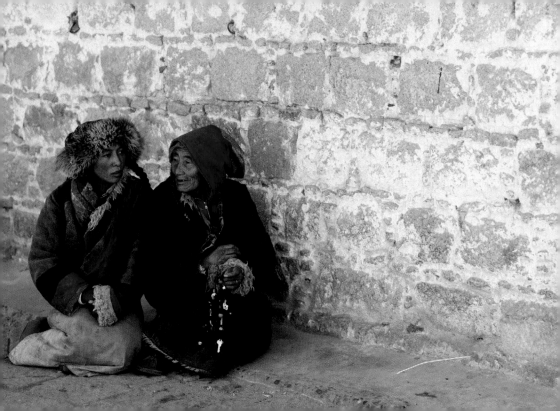

We have only now, only this single eternal moment
opening and unfolding before us, day and night.

Jack Kornfield

A woman combs her hair between two chortens in the village of Tangbe, in the Mustang valley of Nepal.

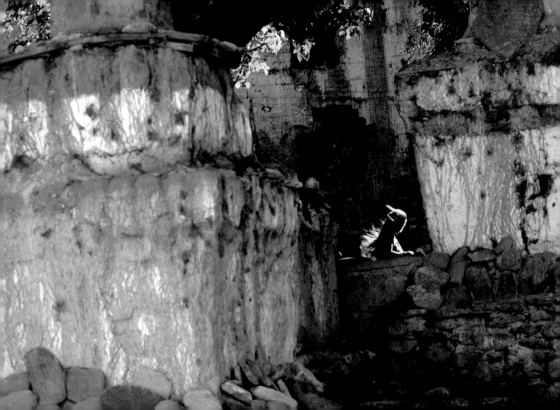

Saying yes, opening up, and loving:
these are the keys that will unlock the prison door.

Arnaud Desjardins (1925–2011)

A young mother in Dolpo, Nepal, wearing a traditional woollen shawl.

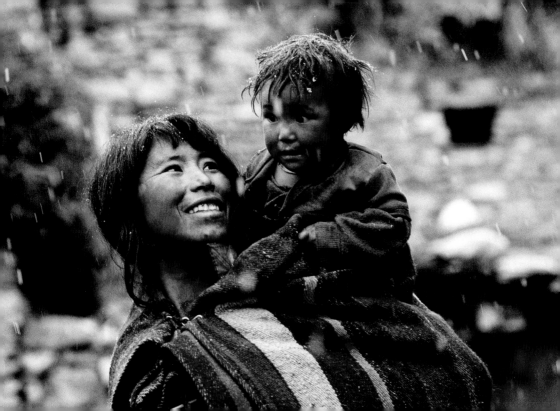

Generosity enacts the quality of non-greed;
it is willingness to give, to share, to let go.
We are inspired to give because of loving feeling,
and in the act of giving we feel more love.

Joseph Goldstein

The broad, well-irrigated valley of Spiti in the Indian Himalayas is home to rich crops of barley.

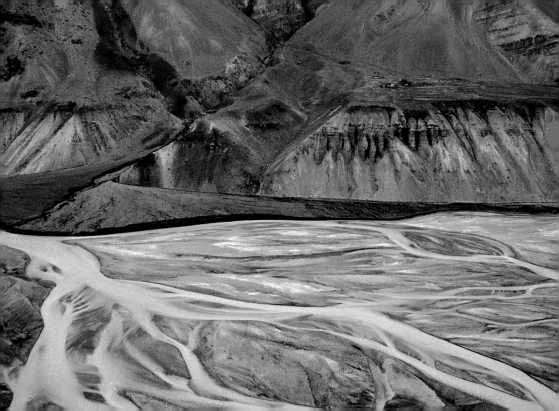

Listening itself is an art. When we listen with a still and concentrated mind, it's possible to actually be responsive to what the words are saying. Sometimes deep insights come in a flash, unexpectedly.

Joseph Goldstein

A wall painting at Rongbuk monastery, at the foot of Everest, damaged during the Chinese cultural revolution.

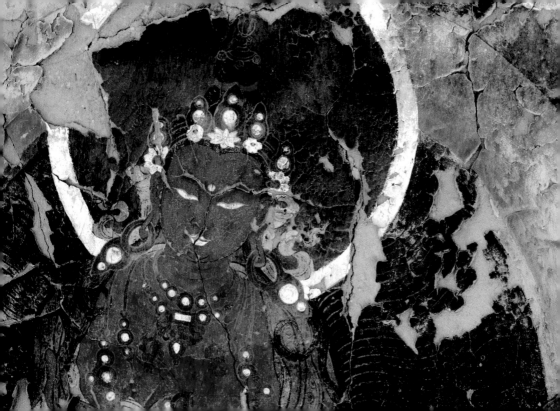

INTERDEPENDENCE & COMPASSION

From concentration comes the birth of wisdom.
Meditation begins with calming the mind and collecting the attention.
In addition to the feelings of restfulness and peace,
the state of concentration also becomes the basis for
deepening insight and wisdom. We find ourselves opening
to the world's suffering as well as to its great beauty.

Joseph Goldstein

A gathering of monks attend an initiation for peace in the heart given by the Dalai Lama in the valley of Kinnaur, India.

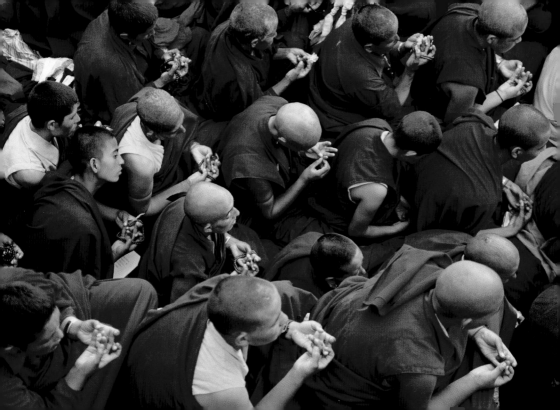

*Each act of generosity is a recognition of our interdependence,
an expression of our Buddha nature.*

Jack Kornfield

Beggars in the bazaar of Bodhgaya, India, during an initiation for peace in the heart given by the Dalai Lama.

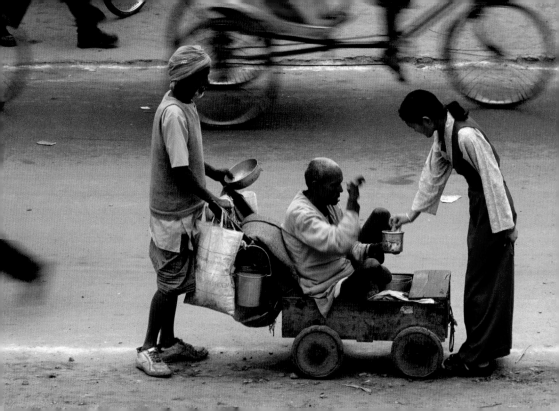

We do not realize often enough that we are dependent on one another;
at the simplest material level, we are all interdependent for our daily needs,
and in this way we owe a debt to all beings.

Kalu Rinpoche (1905–89)

In Zanskar, Abile watches over her great-grandson as he sleeps in their winter home. The temperature is 0°C (32°F).

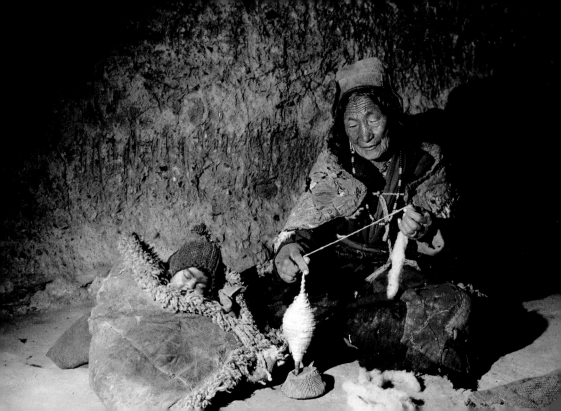

Without the rigidity of concepts, the world becomes
transparent and illuminated, as though lit from within.
With this understanding, the interconnectedness
of all that lives becomes very clear. We see that nothing is stagnant
and nothing is fully separate, that who we are, what we are,
is intimately woven into the nature of life itself.
Out of this sense of connection, love and compassion arise.

Sharon Salzberg

The shepherds of Rupshu leave their snowbound camp, hoping to find pastures for their flocks.

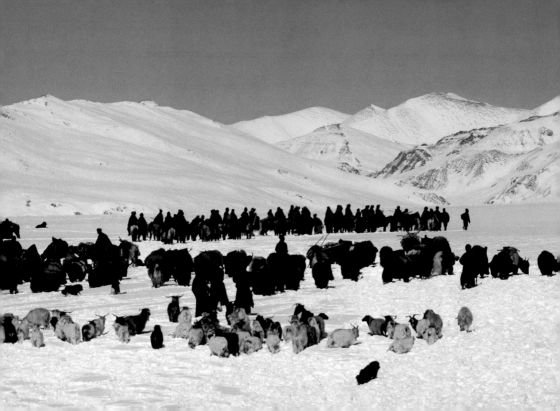

Every conflict begins with thoughts of fear, animosity and aggression,
which pass through some people's minds and spread like wildfire.
The only antidote to these aberrations is to take on fully the suffering of others.

Matthieu Ricard

In Dolpo, Nepal, a pack mule slips in the snow and mud and is reluctant to go any farther.

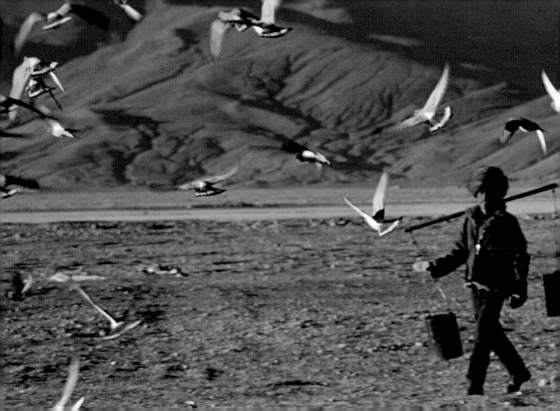

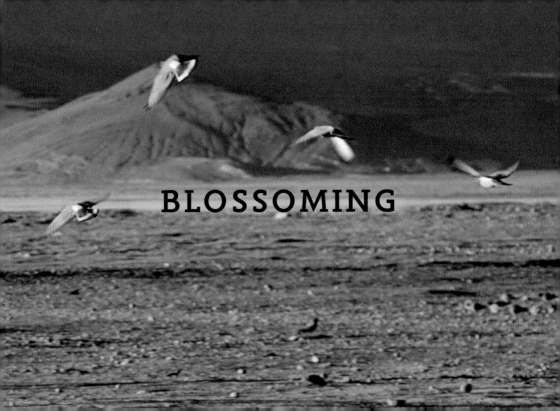

BLOSSOMING

A feeling of warmth creates a kind of openness.
You'll find that all human beings are just like you.

The 14th Dalai Lama

Young novices from a Himalayan monastery arrive in the town of Bodhgaya, India, on a pilgrimage.

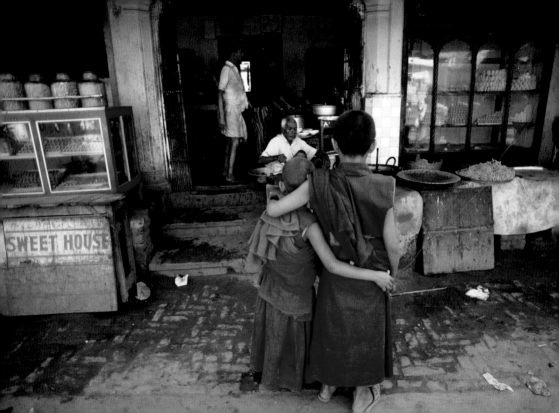

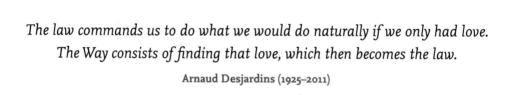

The law commands us to do what we would do naturally if we only had love.
The Way consists of finding that love, which then becomes the law.

Arnaud Desjardins (1925–2011)

Two porters help each other to reach the foot of the sacred mountain of Minya Konka in Tibet.

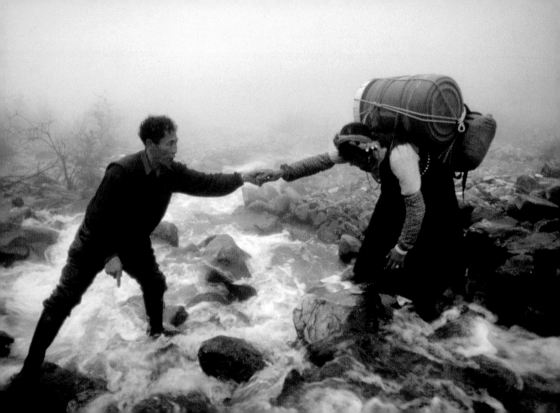

When you speak of adopting a wider perspective,
this includes working cooperatively with other people.

The 14th Dalai Lama

.

Workmen from Dumka on the plains of Bihar, India, are experts at building roads through the Himalayas.

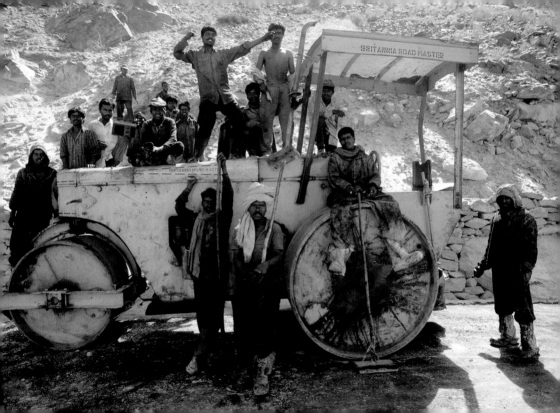

*Let the visions you experience pass through your consciousness
like clouds passing through an empty sky.*

Jack Kornfield

A herd of wild asses, known as kiangs, spend winter on the high plains of Ladakh.

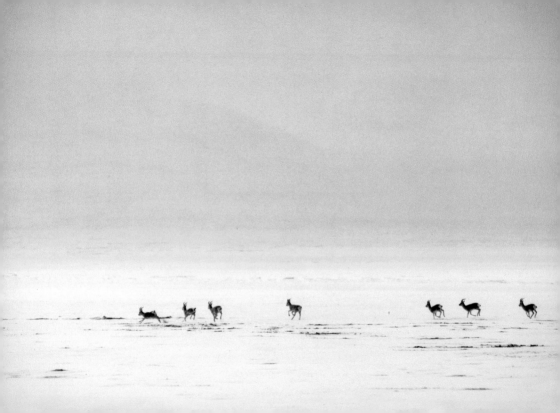

The Buddha discovered what he called the Middle Way,
a way not based on an aversion to the world, nor on attachment,
but a way based on inclusion and compassion.
The Middle Way rests at the centre of all things,
the one great seat in the centre of the world.

Jack Kornfield

Crowned with prayer flags, the stupa of Boudhanath in Nepal holds sacred relics.

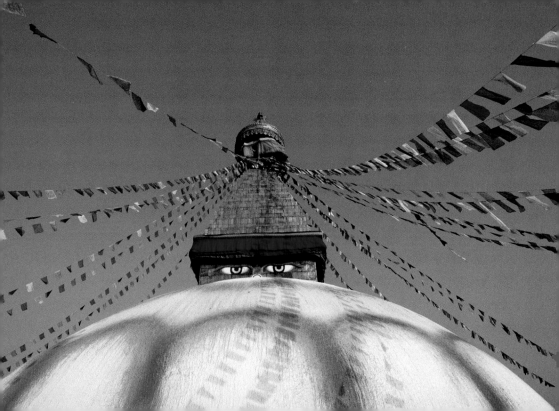

When the mind is haughty, sarcastic, full of conceit and arrogance,
ridiculing, evasive and deceitful, when it is inclined to boast,
or when it is contemptuous of others, abusive and irritable,
then remain still like a piece of wood.

Shantideva (c. 685–763)

On the plains of Zanskar, at a height of 3,500 m (11,500 ft), a horse rests after a long day's journey.

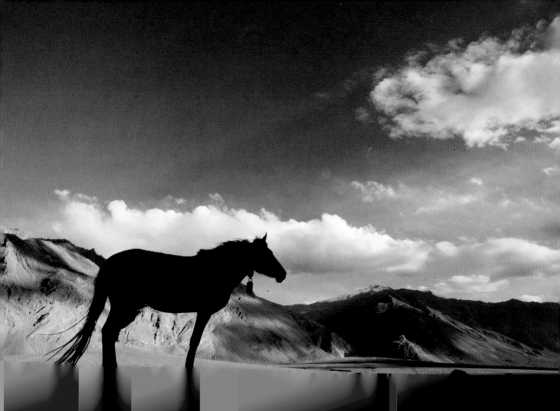

Most of us have spent our lives caught up in plans, expectations, ambitions for the future, in regrets, guilt or shame about the past. To come into the present is to stop the war.

Jack Kornfield

Girls from the village of Laya in Bhutan wear traditional hats made from woven bamboo.

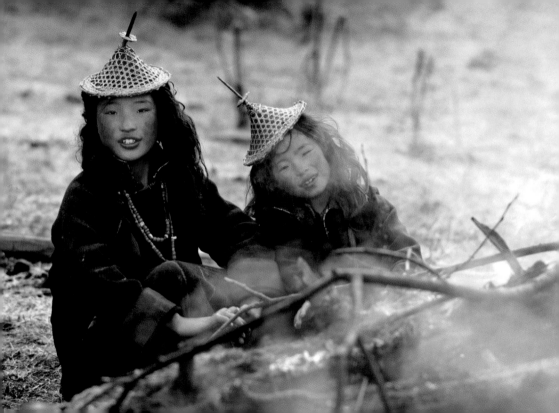

We do not become angry with the stick that hits us,
but with the one who wields the stick.
But the one who wields the stick is impelled by hatred,
so what we should truly hate is hatred itself.

Shantideva (c. 685–763)

Bhutanese farmers try to drive their stubborn yak to pasture.

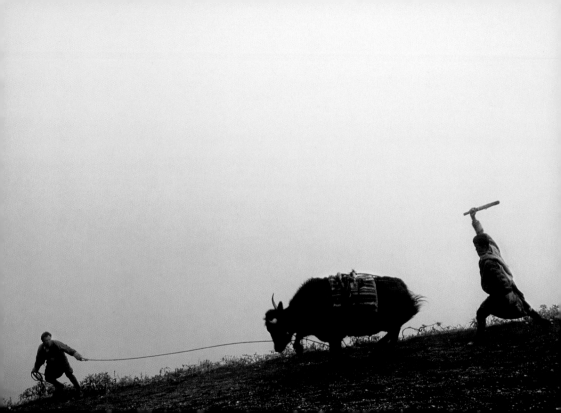

The primary method to overcome social afflictions
is self-discipline in personal life,
through which one attempts to master self-control;
it is very difficult to impose discipline from the outside.

The 14th Dalai Lama

At a school for Tibetan refugee children in Choglamsar, Ladakh, a pupil concentrates on her schoolwork.

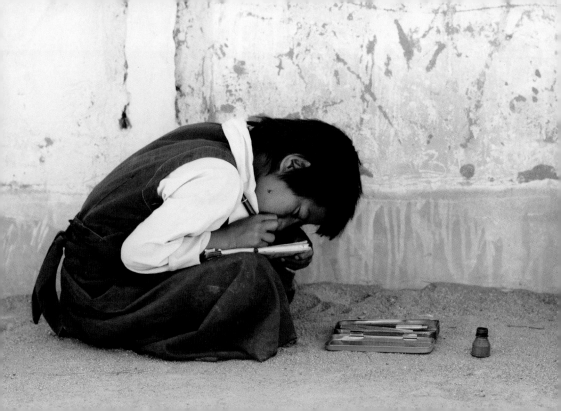

True compassion arises from a healthy sense of self,
from an awareness of who we are that honours our own capacities
and fears, our own feelings and integrity, along with those of others.

Jack Kornfield

Bhutanese villagers hoe their potato fields.

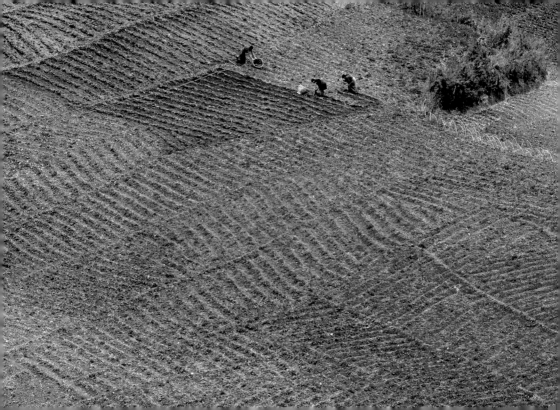

Bring your attention to the pain as if you were gently comforting a child, holding it all in a loving and soothing attention.

Jack Kornfield

A child from the Tibetan valley of Barbung, at the foot of the Dhaulagiri massif in Nepal.

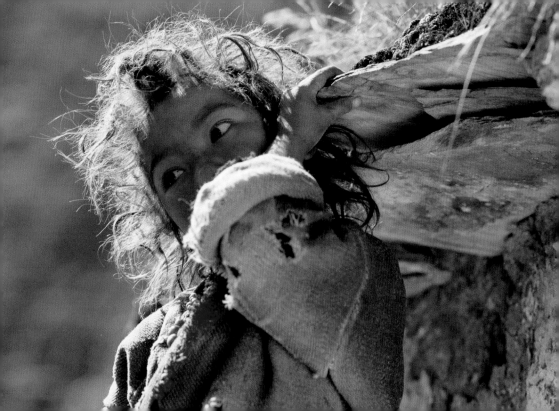

Begin to recite inwardly the following phrases directed to yourself.
You begin with yourself because without loving yourself
it is almost impossible to love others.

May I be filled with loving-kindness.
May I be well.
May I be peaceful and at ease.
May I be happy.

Jack Kornfield

At -30°C (-22°F), a porter warms his hands on the Chadar trail along the frozen Zanskar river.

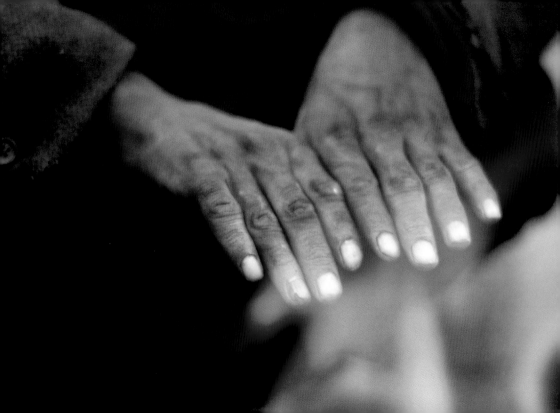

When you meditate, invite yourself to feel the self-esteem,
the dignity, and strong humility of the Buddha that you are.

Sogyal Rinpoche

A village woman from the Tibetan valley of Barbung, at the foot of the Dhaulagiri massif in Nepal.

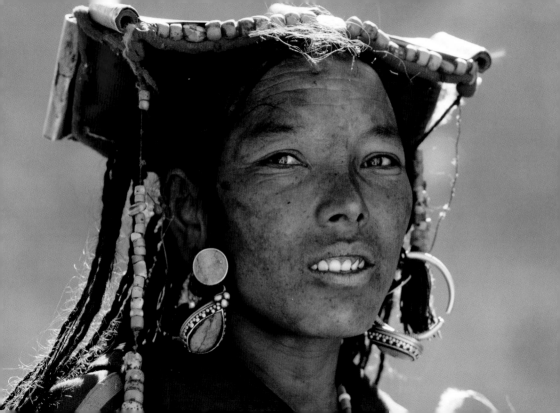

Compassion for ourselves gives rise to the power to transform resentment into forgiveness, hatred into friendliness, and fear into respect for all beings.

Jack Kornfield

In Zanskar, India, terraced fields follow the curves of the mountainous ground.

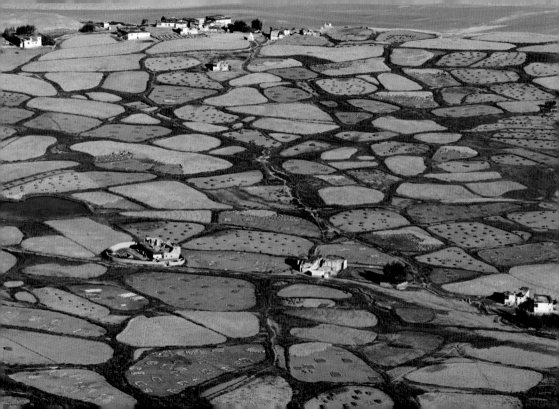

Peace must develop on mutual trust.

The 14th Dalai Lama

This conch shell bracelet is a prized piece of jewelry in Zanskar, India.

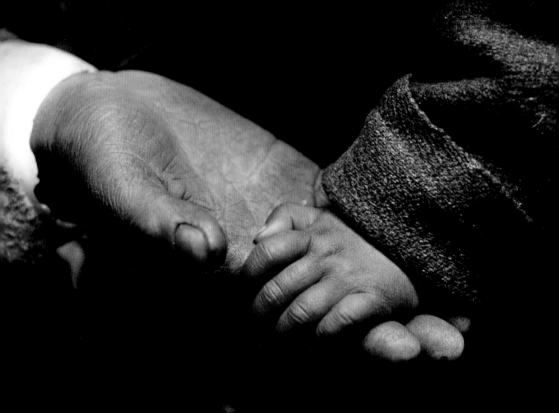

This is not a matter of changing anything
but of not grasping anything, and
of opening our eyes and our heart.

Jack Kornfield

In a village house in Bhutan.

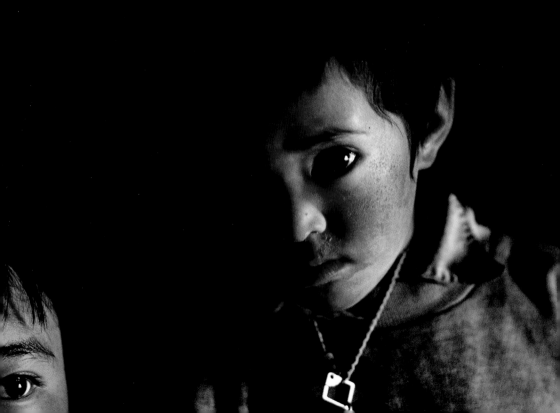

All those who are unhappy in the world are so
as a result of their desire for their own happiness.
All those who are happy in the world are so
as a result of their desire for the happiness of others.

Shantideva (c. 685–763)

Anila Sherab, a young German nun who has taken orders with the Tibetan Buddhist community.

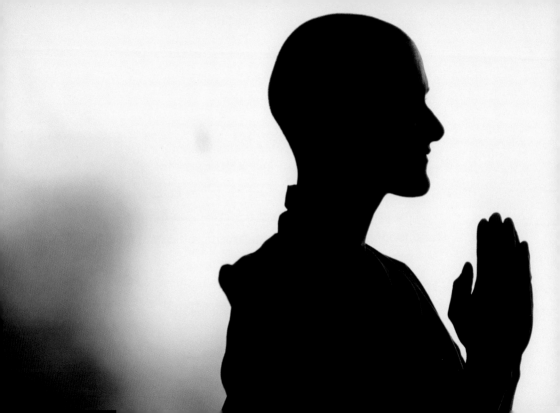

In the valley, we have some friends whom we love,
some enemies whom we hate,
and all the others whom we do not know.
This perception of people is distorted and limited,
and produces nothing but attachment and aggression.

Dilgo Khyentse Rinpoche (1910–91)

Two donkeys nibble on a few stalks of grass in the dry valley of Rupshu in Ladakh, India.

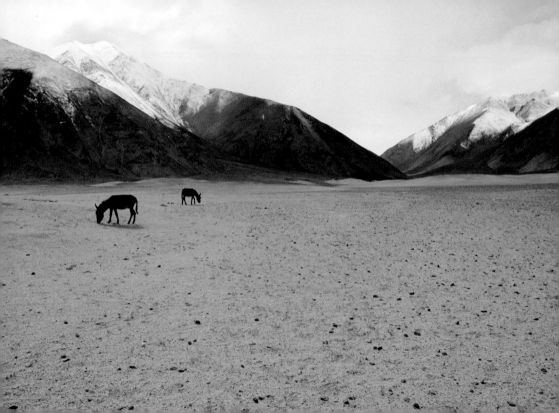

Love, love, take the first step. Everything depends on love.
Even professional success means feeling that life loves you,
that your managers, bosses and colleagues are not enemies.

Arnaud Desjardins (1925–2011)

At a wedding in Zanskar, the fathers of the bride and groom exchange cups of barley beer, known as *chang*.

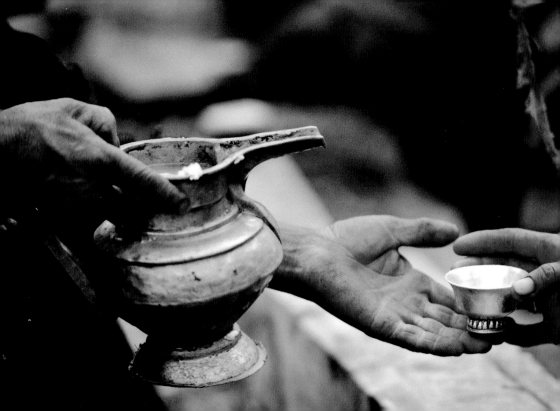

Limbs are cherished because they are parts of the body:
why then are other people not cherished
because they are parts of humanity?

Shantideva (c. 685–763)

A young woman from Zanskar gets ready to attend a village wedding.

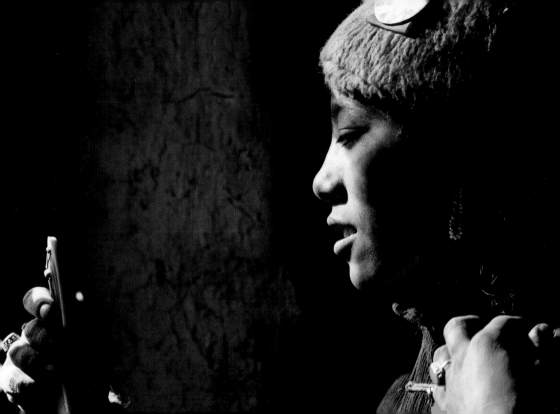

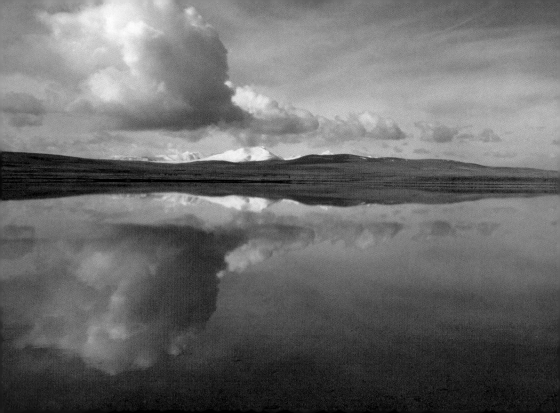

SOWING SEEDS

*We can bring a heart of understanding and compassion
to a world that needs it so much.*

Jack Kornfield

Large Buddhist gatherings in Bodhgaya, India, attract beggars from elsewhere in the Bihar region.

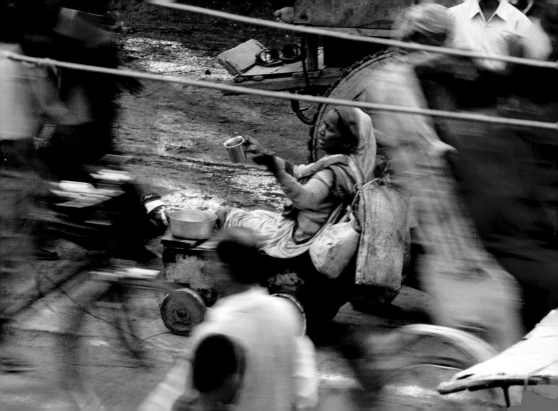

If we think about the vast majority of human problems,
both on a personal and on a worldwide scale,
it seems that they stem from an inability to feel sincerely
involved with others, and to put ourselves in their place.
Violence is inconceivable if everyone is genuinely
concerned with the happiness of others.

Matthieu Ricard

Prayer flags in the wind in the Himalayas.

*Sending and taking is regarded as a
natural course of exchange; it just takes place.*

Chögyam Trungpa (1939–1987)

At a major Buddhist gathering at Bodhgaya, India.

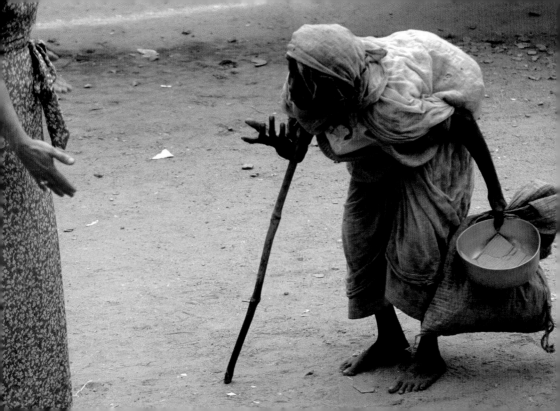

True love for our neighbour will be translated
into courage and strength.
The more we develop love for others,
the more confidence we will have in ourselves.

The 14th Dalai Lama

Tibetan monks pray beneath the branches of the sacred Bodhi tree during a Buddhist teaching at Bodhgaya, India.

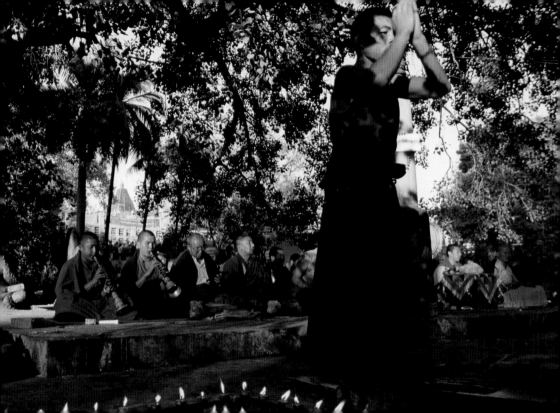

It is important to understand how much
your own happiness is linked to that of others.
There is no individual happiness totally independent of others.

The 14th Dalai Lama

On the plateaux of Rupshu in Ladakh, shepherds gather to watch a troupe of travelling performers putting on a show.

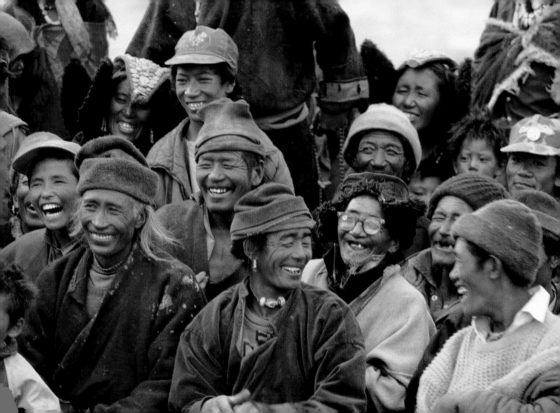

You can feel compassion regardless of whether you view the other person as a friend or an enemy. It is based on the other's fundamental rights rather than your own mental projection.

The 14th Dalai Lama

Workers are recruited from Bihar to build a military road in Ladakh. They melt tar by the roadside.

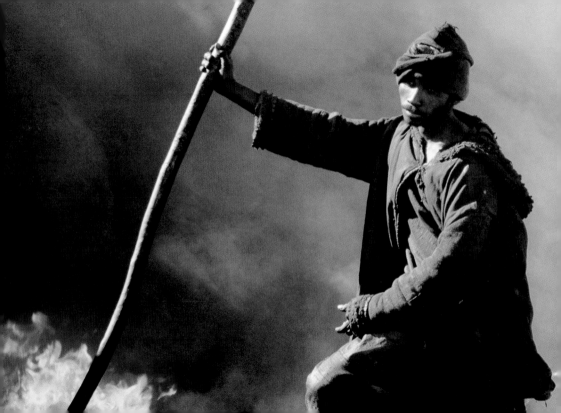

*Notions such as 'my country', 'your country',
'my religion', 'your religion' have become minor.
We must, on the contrary, insist on the fact that
the other person is as worthy as we are.
This is humanity! This is why we must
re-examine our educational system.*

The 14th Dalai Lama

The shepherds of Rupshu in Ladakh move their flocks from camp to camp.

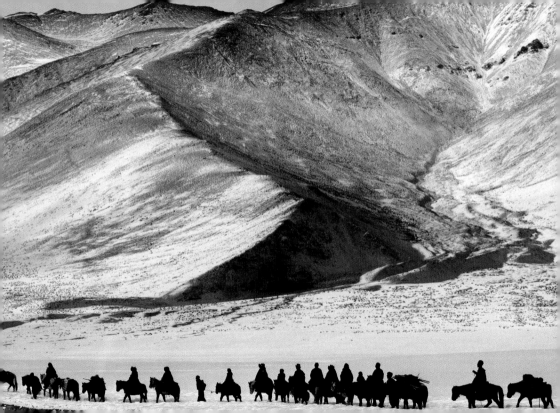

What you do for yourself – any gesture of kindness,
any gesture of gentleness, any gesture of honesty
and clear seeing toward yourself – will affect
how you experience your world.
In fact, it will transform how you experience the world.
What you do for yourself, you're doing for others,
and what you do for others, you're doing for yourself.

Pema Chödrön

Tibetan pilgrims prostrate themselves in front of Tashilumpo monastery in Shigatse, Tibet.

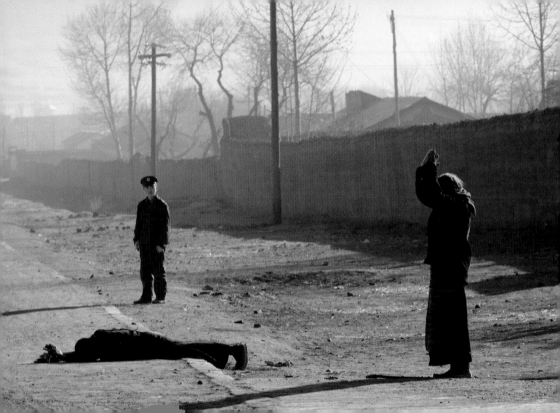

Every morning, our first thought should be
a wish to devote the day to the good of all living beings.

Dilgo Khyentse Rinpoche (1910–91)

In the Himalayan valleys of Zanskar, flowers are traditionally offered to travellers who have crossed a mountain pass.

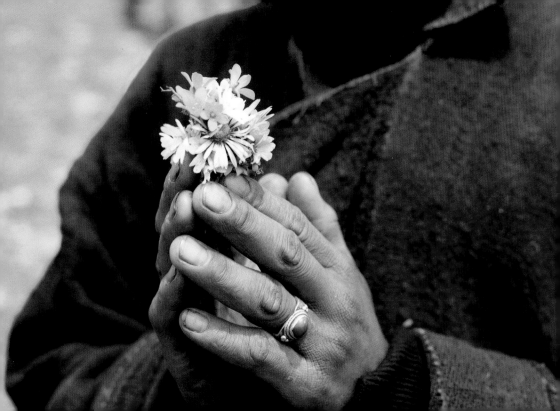

Compassion is the heart's response to sorrow.
We share in the beauty of life and in the ocean of tears.
The sorrow of life is part of each of our hearts and part of what
connects us with one another. It brings with it tenderness, mercy,
and an all-embracing kindness that can touch every being.

Jack Kornfield

In winter in Zanskar, each family shares a single room. Young goats are brought inside to improve their chance of survival.

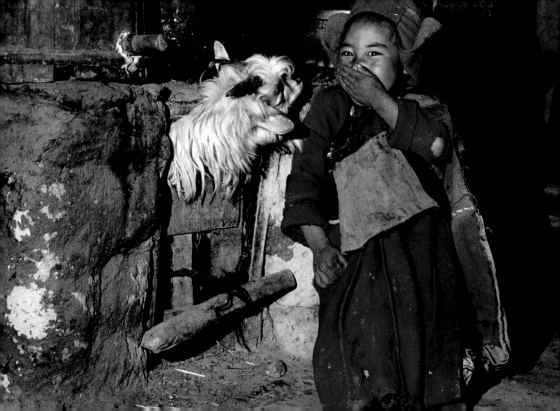

Where can fish and animals be taken where they could not be killed?
The renunciation of doing harm is the perfection of discipline.

Shantideva (c. 685–763)

Tsering Norbu, a boy from the Mustang valley in Nepal.

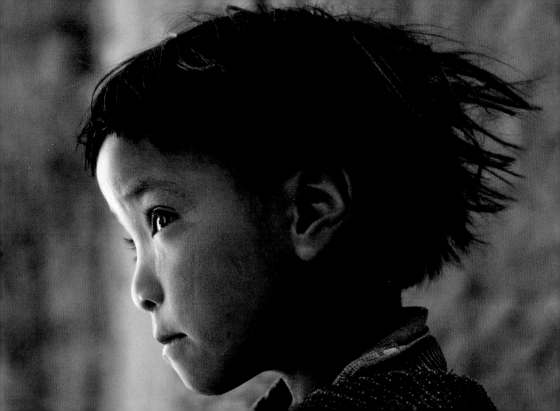

You will not reach love without immense gratitude in your heart.

Arnaud Desjardins (1925–2011)

A young woman in the village of Laya, Bhutan.

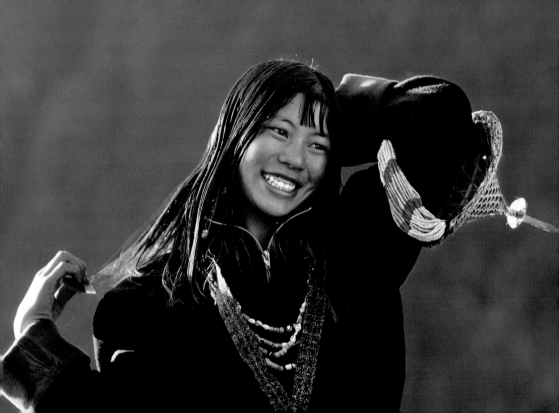

Just as there is no point of darkness in the sun,
For the yogi, the universe and sentient beings are all deities,
And he is fulfilled.

Shabkar (1781–1851)

Wall painting of a Tibetan deity in the chapel of Lingshed monastery, in Ladakh, India.

All of spiritual practice is a matter of relationship:
to ourselves, to others, to life's situations.

Jack Kornfield

A shepherd and his son leave their camp in Ladakh in search of pastures for their flock.

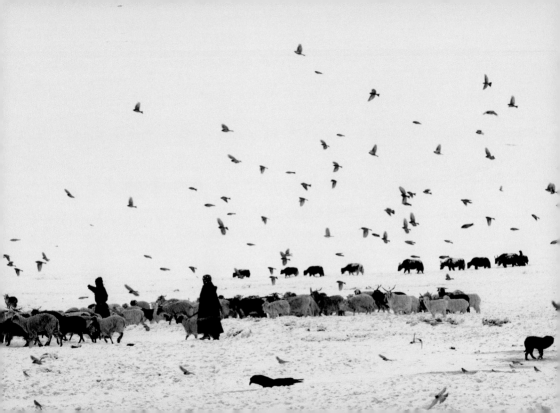

The forces which move the cosmos are no different from those which move the human soul.

Lama Anagarika Govinda (1898–1985)

Two villagers from Zanskar return to their village from the nearby water mill, under a darkening monsoon sky.

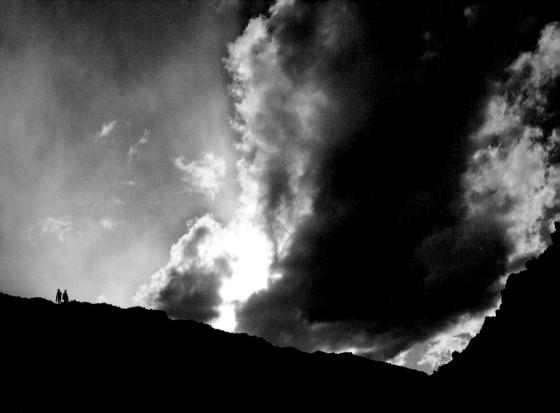

True spirituality is to be aware that if we are interdependent with everything and everyone else, even our smallest, least significant thought, word, and action have real consequences throughout the universe.

Sogyal Rinpoche

On the high plateaux of Rupshu in Ladakh, a baby wakes up to greet his parents as they come home from the fields.

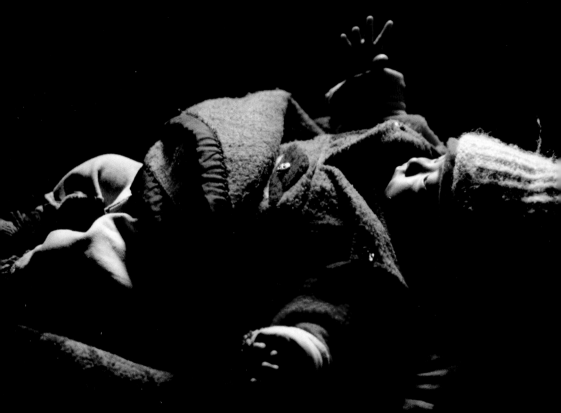

Only in the reality of the present can we love,
can we awaken, can we find peace and understanding
and connection with ourselves and the world.

Jack Kornfield

In summer in Ladakh, a shepherd drives his goats up to the pastures of Karnak, at a height of 4,000 m (13,100 ft).

All that is visible clings to the invisible,
the audible to the inaudible,
the tangible to the intangible,
Perhaps the thinkable to the unthinkable.

Lama Anagarika Govinda (1898–1985)

The Chadar trail, stretching 150 km (93 miles) along the frozen Zanskar river, is the only winter route from Ladakh to Zanskar.

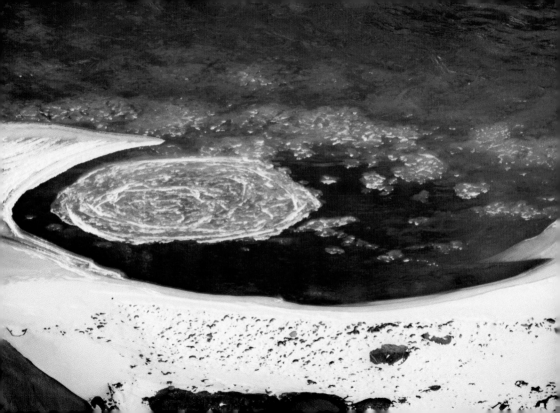

*Reality, enlightenment or the divine must shine
through every moment or it is not genuine.*

Jack Kornfield

A pilgrim prays in Bodhgaya, India, during an initiation ceremony for peace in the heart given by the Dalai Lama.

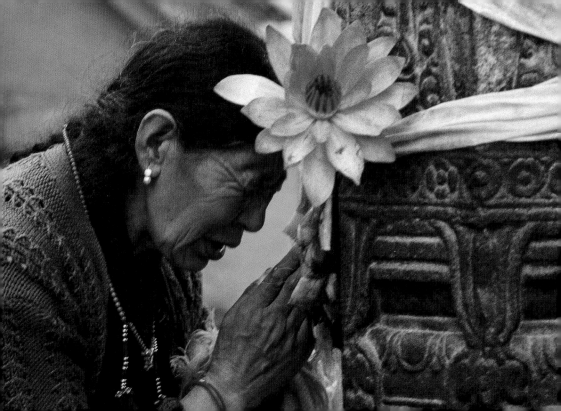

Glossary

Compassion: the desire to liberate all living beings from suffering and its causes (negative actions and ignorance). It is the complement of love (the wish for all beings to know happiness and its causes), of altruistic joy (rejoicing in the qualities of another) and of equanimity, which extends these feelings to all beings without distinction, friends, strangers and foes alike.

Dharma: a word of many meanings. At its broadest, it signifies everything that can be known. Most often, it denotes the totality of the teachings of the Buddhas and great teachers. There are two aspects to this: the dharma of the scriptures, which underpins these teachings, and the dharma of realization, which is the outcome of spiritual practice.

Enlightenment: synonymous with the condition of being a Buddha, Enlightenment is the ultimate accomplishment of spiritual growth, supreme inner knowledge, allied to infinite compassion. Perfect understanding of both relative existence (the way things appear to us) and of ultimate existence (their true nature) of the mind and of the world of phenomena. This knowledge is the basic antidote to ignorance and therefore to suffering.

Ignorance: an erroneous way of perceiving beings and things, attributing them with real, independent, solid and intrinsic existence.

Impermanence: there are two kinds, gross and subtle. Gross impermanence refers to visible changes. Subtle impermanence is the fact that nothing remains the same for more than the shortest conceivable moment of time.

Karma: a Sanskrit word meaning 'action', usually translated as 'causality of actions'. The Buddha taught that the destinies of beings, along with their joy, their suffering and their perception of the universe, are not due to either chance or the will of an all-powerful entity but are the outcome of their past actions, words and thoughts. Similarly, their future is determined by the positive or negative quality of their present actions. Collective karma defines our general perception of the world, while individual karma determines our personal experiences.

Meditation: process of familiarizing oneself with a new perception of things. Analytical meditation can take as its subject something on which to reflect (the notion of impermanence, for example) or a quality one wishes to develop (such as love or compassion). Contemplative meditation allows us to recognize the ultimate nature of mind and to remain in that nature, beyond conceptual thought.

Samsara: the cycle of existence, marked by suffering and the frustration created by ignorance and the afflictive emotions it causes. It is only by knowing emptiness and thus dispelling all negative emotions that one may recognize the nature of mind and free oneself from samsara.

Suffering: the first of the Four Noble Truths, which are: 1) the truth of suffering, which we need to recognize as omnipresent in the cycle of existences; 2) the truth of the causes of suffering – the negative emotions we need to eliminate; 3) the truth of the Path of spiritual development that we must travel in order to achieve liberation; and 4) the truth of the end of suffering, resulting from spiritual training, or Enlightenment.

Wisdoms (Five): five aspects of Enlightenment: equalizing wisdom, mirror-like wisdom, discriminating wisdom, all-accomplishing wisdom, and wisdom of ultimate reality. These five wisdoms can only be actualized after the two veils which prevent Enlightenment have been dispersed: the veil of emotions that cloud perception and the veil masking knowledge of the ultimate nature of phenomena.

Bibliography

His Holiness the 14th Dalai Lama, *Beyond Dogma: Dialogues and Discourses*, North Atlantic Books, Berkeley, CA, 1996

His Holiness the 14th Dalai Lama, *Conseils du cœur*, Presses de la Renaissance, Paris, 2001

His Holiness the 14th Dalai Lama and Howard C. Cutler, *The Art of Happiness: A Handbook for Living*, Hodder & Stoughton, London, 1999

Chödrön Pema, *When Things Fall Apart: Heart Advice for Difficult Times*, Shambhala, Boston; HarperCollins Ltd, London, 1997

Chögyam Trungpa, *Training the Mind and Cultivating Lovingkindness*, Diana J. Mukpo; Shambhala, Boston, 1993

Arnaud Desjardins, *L'Audace de vivre*, Éditions de La Table Ronde, Paris, 1989

Dilgo Khyentse Rinpoche, *Les Cent conseils de Padampa Sangyé*, Éditions Padmakara, Saint-Léon-sur-Vézère, 2000

Joseph Goldstein, *One Dharma: The Emerging Western Buddhism*, Insight Meditation Society; HarperCollins, San Francisco, 2002

Lama Anagarika Govinda, *Les Fondements de la mystique tibétaine*, Albin Michel, Paris, 1960

Kalu Rinpoche, *La Voie du Bouddha selon la tradition tibétaine*, Éditions du Seuil, Paris, 1993

Jack Kornfield, *A Path with Heart: A Guide Through the Perils and Promises of Spiritual Life*, Random House, New York, 1993

Milarepa, *The Hundred Thousand Songs of Milarepa*

Matthieu Ricard, *L'Infini dans la paume de la main*, Nil Éditions, Paris, 2000

Sharon Salzberg, *Lovingkindness: The Revolutionary Art of Happiness*, Shambhala, Boston, 2002

Shabkar, *Autobiographie d'un yogi tibétain*, Albin Michel, Paris, 1998

Shantideva, *A Guide to the Bodhisattva's Way of Life*

Sogyal Rinpoche, *The Tibetan Book of Living and Dying*, Rigpa Fellowship; HarperCollins, New York; Random House, London, 1993

When you are master of your body, word and mind,
you shall rejoice in perfect serenity.

Shabkar (1781–1851)